THE KURTHERIAN GAMBIT ART BOOK

By
Andrew Dobell
&
Michael Anderle

Foreword by
Michael Anderle

TABLE OF CONTENTS

FOREWORD
By Michael Anderle

The Man, The Myth, The LEGEND...
Andrew Dobell

When I put out my first books, I did the covers myself (kids, don't try this at home.) It wasn't for lack of money (although lack of knowledge was a factor), but rather because I didn't know if the series would have legs.

Whether it would sell or not.

By the time it was obvious even to me that these stories were going to sell well, I was behind the eight ball and already working on books six, seven and eight.

I was on either KBoards or 20Booksto50k tooling around when a post caught my eye. Andrew had put up information about his cosplay efforts and had left a handy-dandy link to his website. So I clicked...and then I drooled. Then I clicked around and drooled some more.

I wanted something like the images on his website for my Bethany Anne.

I reached out to Andrew and we started talking about what it would take to set up a photo shoot (I didn't want my model to be plastered on everyone else's covers. This happens a fair amount with stock images.)

Then, I learned that working with models is fickle and takes a lot of time. However, the effort was SO worth it.

How worth it? I'm glad you asked.

In November of 2017, I had a private dinner for eighty people in Las Vegas, Nevada. We were enjoying ourselves on the top floor of the Delano Hotel, overlooking the Las Vegas Blvd lights from the south. When we finished our drinks, it was time to herd everyone to the dinner area.

I was at the back, encouraging everyone to move down this longer hall (it had a dog-leg left for twenty feet, then right again for about ten feet before it entered the final dinner room.)

It was going SLOW. So slow and from the back, I couldn't understand why the group of people was taking so long to move through this hallway. If you had been looking backward, you would have seen my head pop up as I jumped (several times) to try to see what was going on.

Was one of the doors closed and locked? Did we have some sort of obstruction?
We did, sort of.

You see, I had placed a six-foot-tall image of Bethany Anne at the end (one of those where you have a base, and pull it up?)
By the time I finally got to that location, I realized people were taking pictures with Bethany Anne. Somehow, she had become a celebrity; someone to take a selfie with at the event.

THAT is when you know you are successful.

It was a cool feeling for me that night, and later I found out that it was for Andrew as well, to see others taking a picture with your character.

Andrew has pulled together images published, not previously seen, and my original cover art (which didn't need to be seen ever again, thank you very little.) <grin>

I hope you enjoy these images and a little background on how the Kurtherian Gambit art came to be.

Ad Aeternitatem,

Michael Anderle

INTRODUCTION

Welcome to the first, Art of the Kurtherian Gambit book by myself, Andrew Dobell.

Michael Anderle was actually the first Author to commission me to do a book cover for a novel, and I am very grateful to him that he took a chance on me. I had of course been doing artwork professionally for years beforehand, but Death Becomes Her was the first Novel - besides my own - that I had been commissioned to do.

Back then, I had no idea that those first few books, for an upcoming Author who I had never heard of, would grow into the empire that it is now. I think I was one of the first collaborators to work within the Kurtherian Gambit universe.

Since then, I've worked with many of Michael's other collaborators, including Craig Martelle, Amy Duboff, Tom Dublin, Ell Leigh Clarke, Justin Sloan, Sarah Noffke, J N Chaney, and more.

As the back catalogue of Art grew, it occurred to me that a collected art book of these covers might be something that you, dear readers, might like to have on your shelf.

So, with Michael's blessing, the idea of an Artbook was created.

Within these pages, you will find most of the Art I have created for the Kurtherian Gambit universe novels, without the text that is usually on top of them.

I've included some behind the scenes photos of the shoots, some of the original model shots that were used to create the covers, and some previously unpublished images, that have not seen print before this book.

I hope you like and enjoy what you see in these pages.

Many Thanks,
Andrew Dobell

10th Sept 2018, UK.

THE KURTHERIAN GAMBIT

BOOK 1 - DEATH BECOMES HER

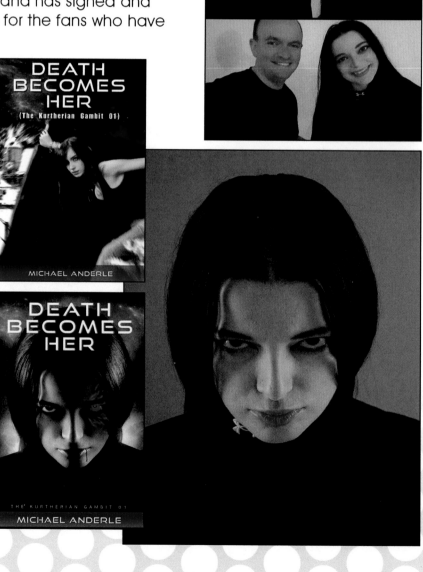

This was the first cover I created for Michael Anderle, following the shoot, the first of many, that I did for this series of books.

Shoots are always challenging to organise, and we went through many choices for the role of Bethany Anne, until Michael eventually settled on Helen Diaz for the Role.

Helen is a friendly professional model, and a little crazy as well. She was the perfect choice for Bethany Anne, and I don't think I could imagine anyone else in the role now. She is BA.

She has also owned the role, and has signed and shipped, books and canvas's for the fans who have tracked her down.

Also, check out the original cover by Michael here --->

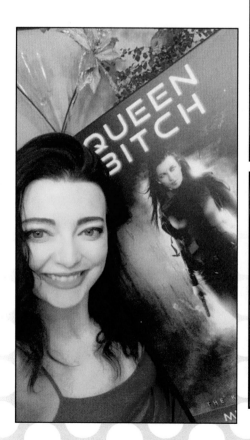

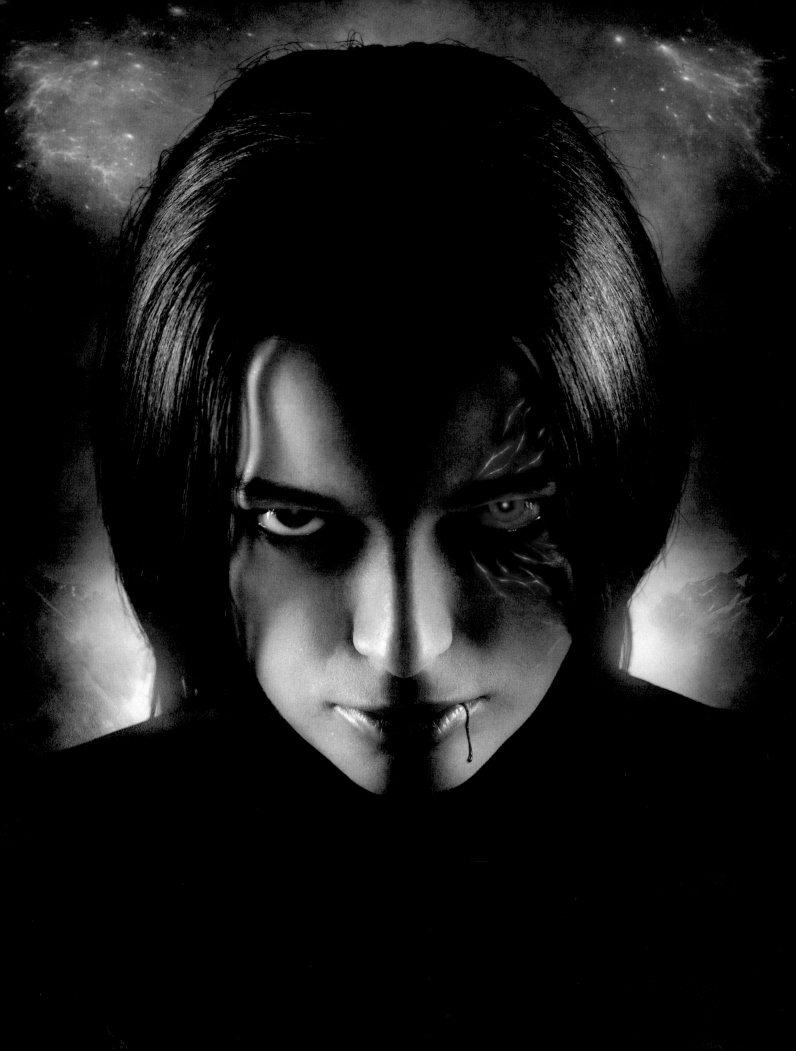

THE KURTHERIAN GAMBIT

BOOK 1- DEATH BECOMES HER - VERSION 2

The first cover for book 1 was iconic and eye catching, and it really worked. The idea for the headshot was entirely Michaels, and he'd come up with it before the shoot took place, allowing me to shoot images specifically for that cover.

As time passed, the idea of doing something different came up, and a new idea for book 1 was settled on.

So, here you can see the full, un-cropped artwork for Death Becomes her.

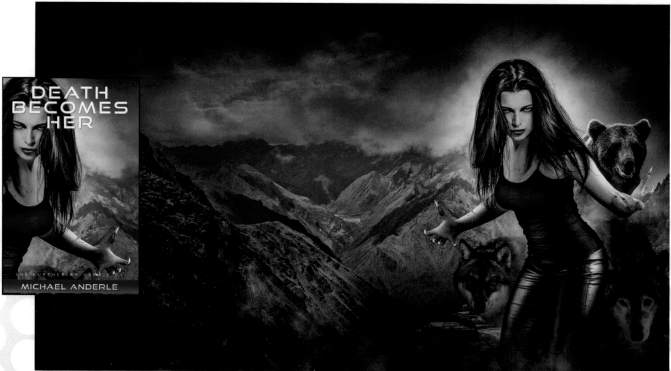

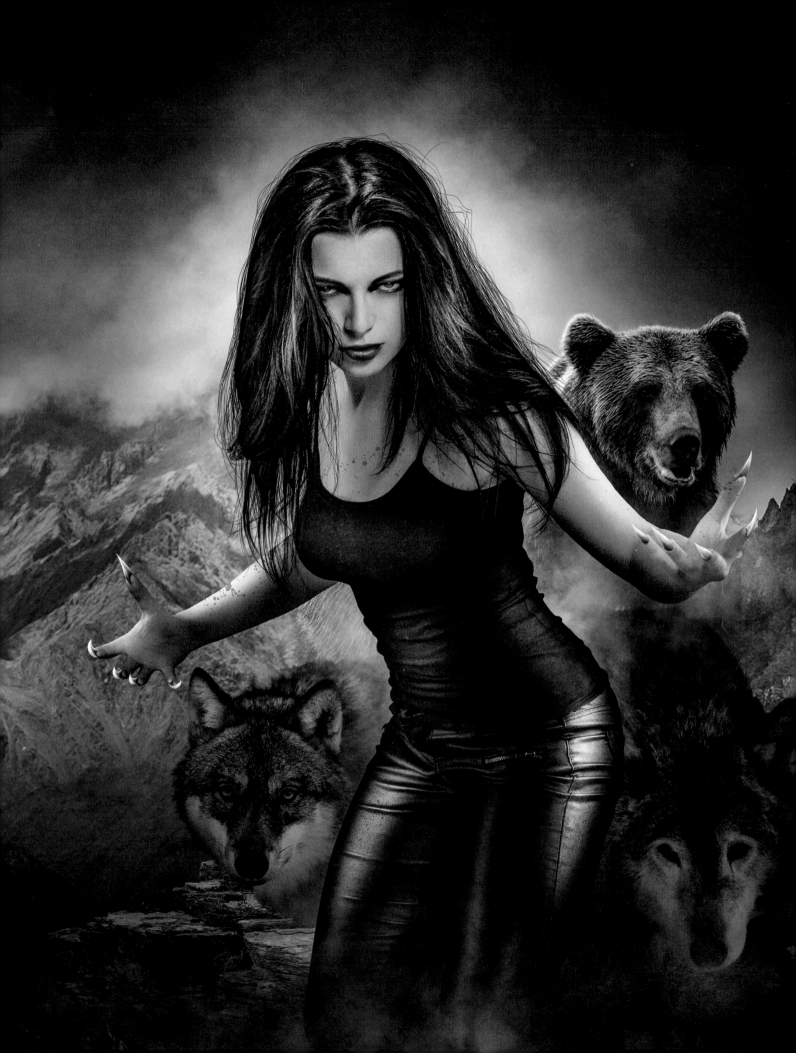

THE KURTHERIAN GAMBIT

BOOK 2 - QUEEN BITCH

A simple and iconic shot of Bethany Anne on her way to take care of business.

The original cover
-->

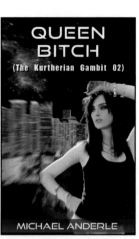

Vampires and werewolves watch out, the Queen Bitch is on her way!

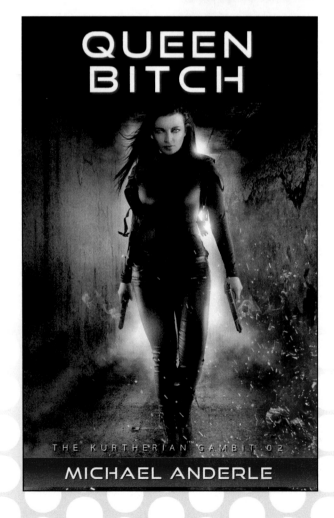

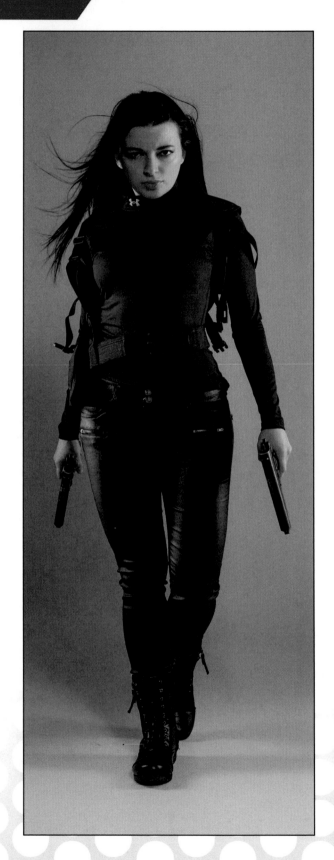

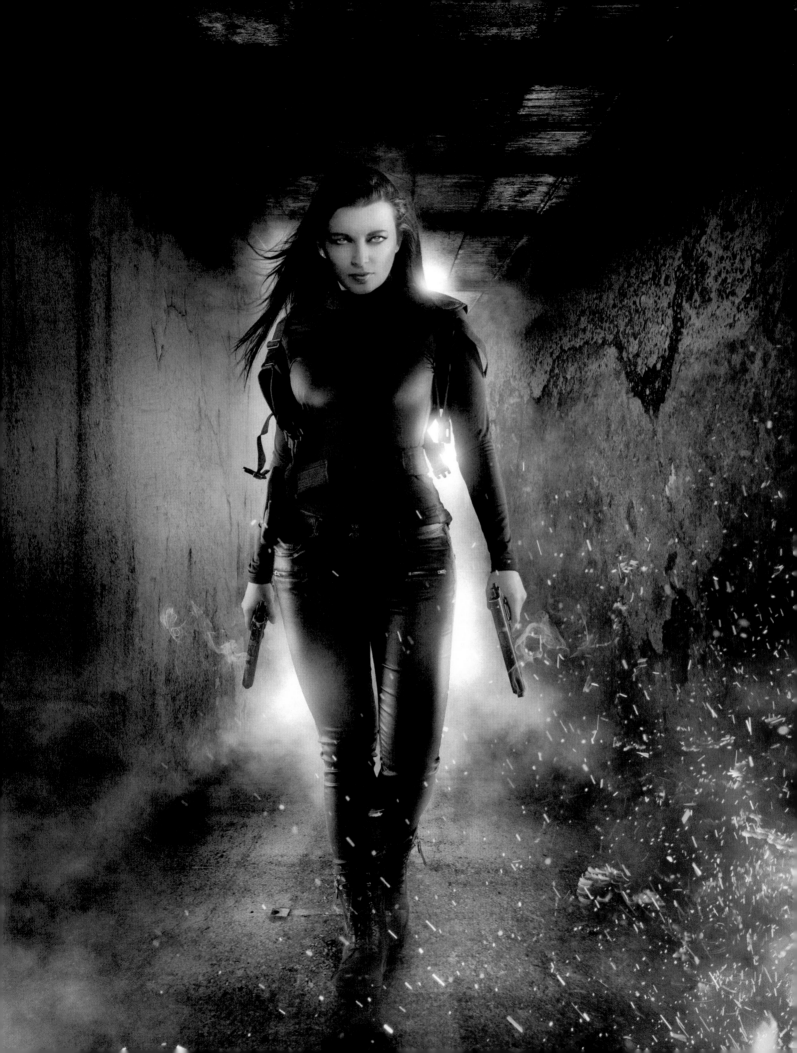

Once the initial first pass at the cover is done, it's sent to the Author for feedback, and changes are made based on that feedback.

On this cover, a gap in the shafts of light made it look like BA had hung herself. So, that had to be changed.

You can see the original cover below.

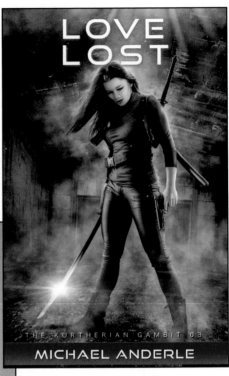

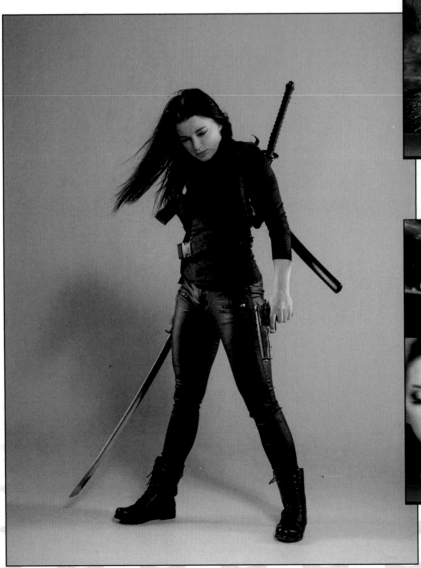

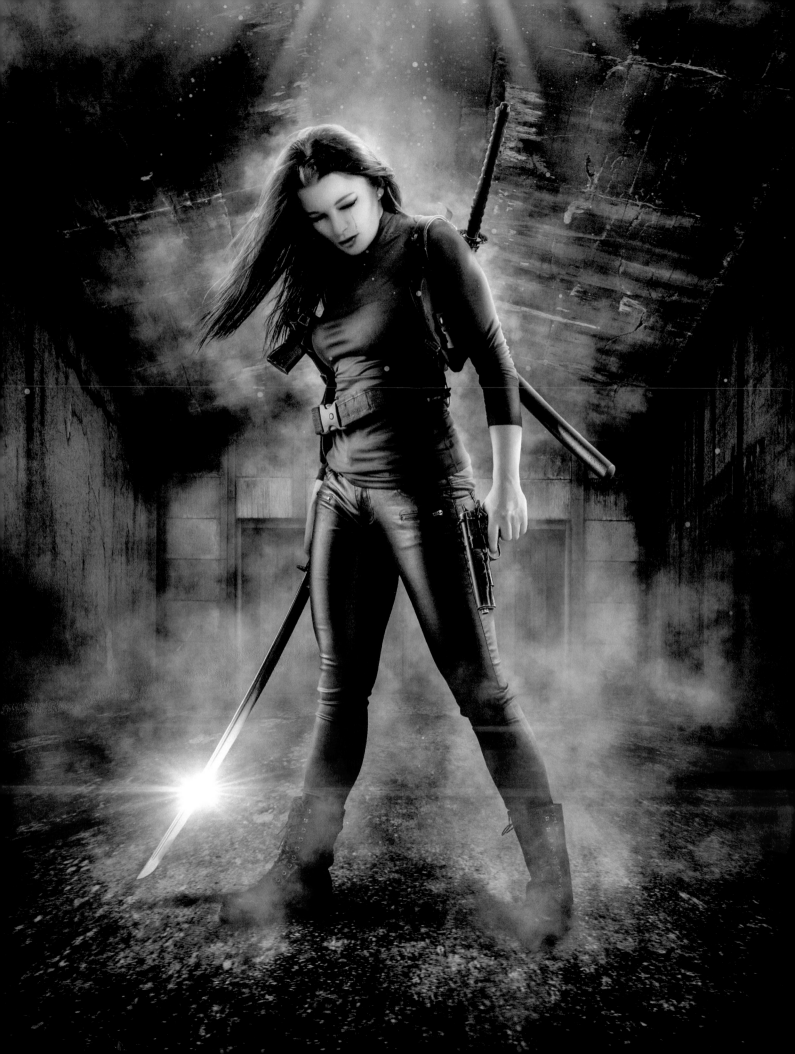

THE KURTHERIAN GAMBIT
Book 4 - Bite This

One of my favourites from these early Bethany Anne books. A simple shot of her looking ready to show some fools who's boss.

Helen was fun to work with on these, although, like many models, she was not used to this kind of 'acting'. She did a great job though.

You can see the original cover below.

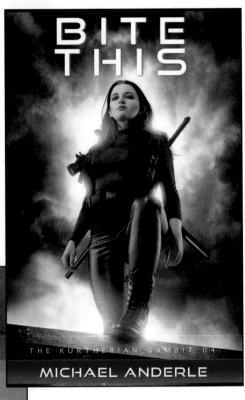

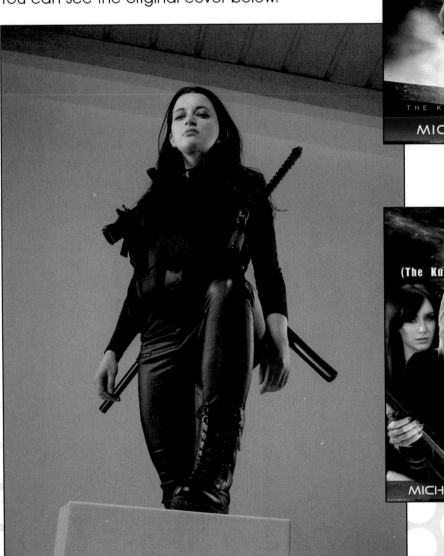

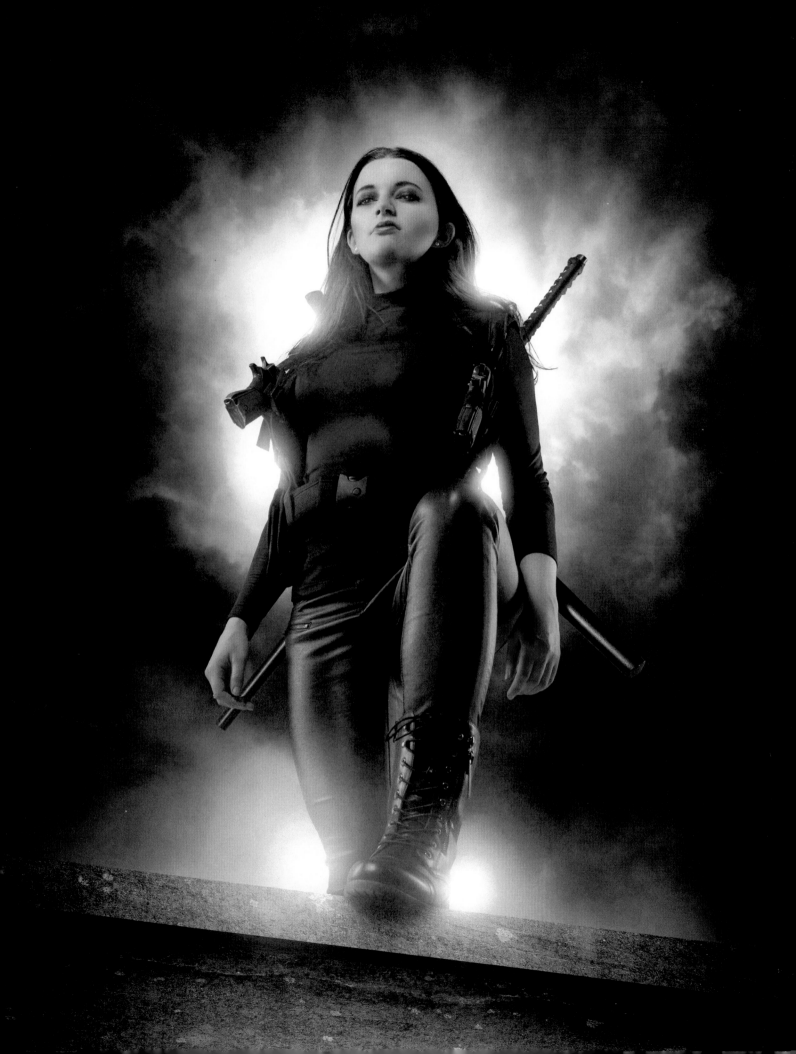

THE KURTHERIAN GAMBIT
BOOK 5 - NEVER FORSAKEN

As you can see below, the dog, Ashur, was not there at the shoot. He was taken from a stock image.

Bethany Anne certainly does a lot of walking towards the camera!

You can see the original cover below.

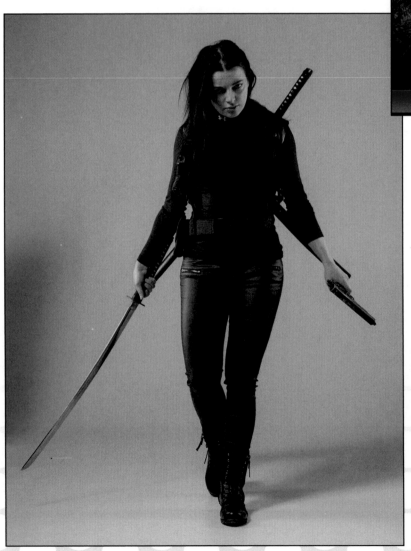

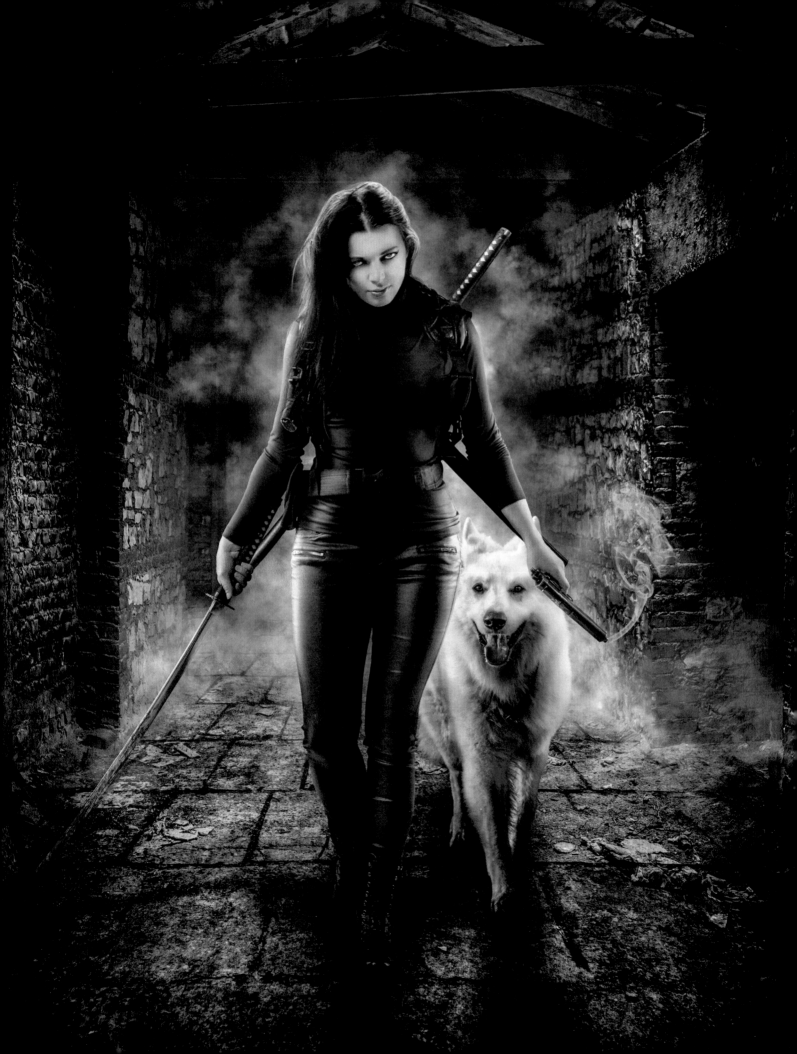

Bethany Anne leads a strike team into the caves to hunt for some Forsaken.

As a part of the preparation for the shoot, we bought a matching pair of Katana Swords for Bethany Anne to use.
They're still in my office, and are surprisingly heavy.

You can see the original cover below.

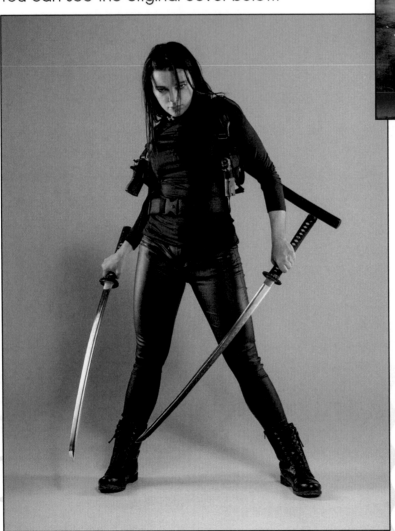

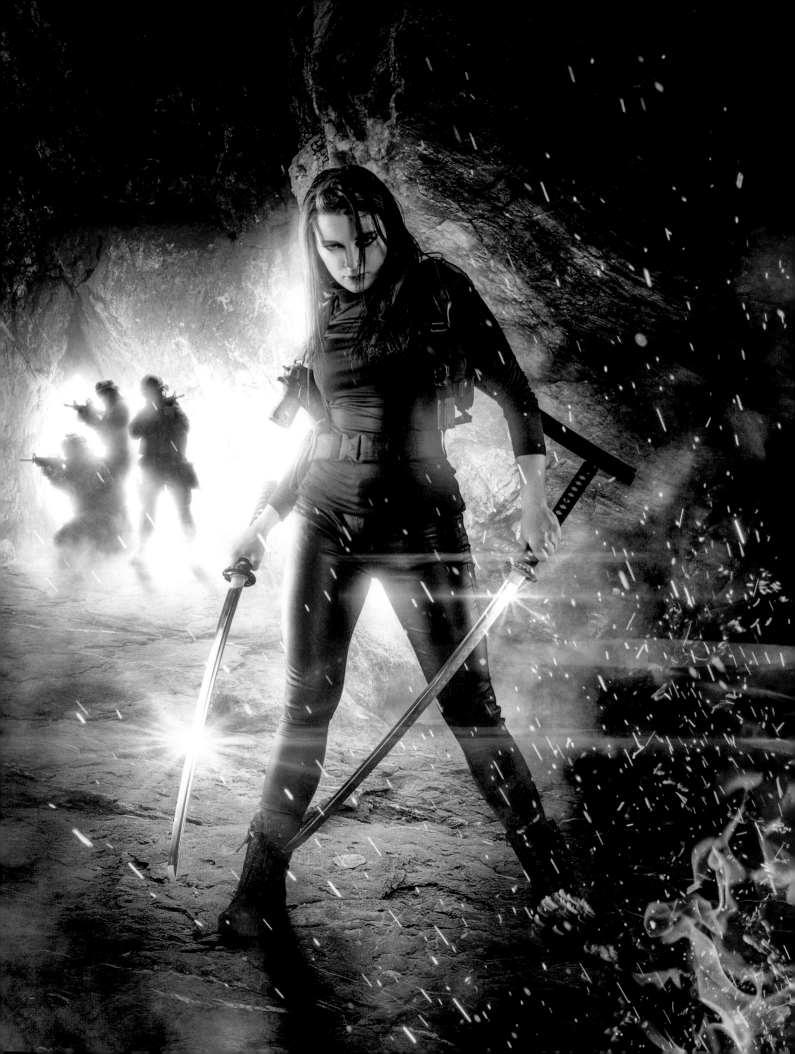

Occasionally, the first concept for a cover just doesn't work, and even when we've finished that cover, we know that it either won't work or won't fit the book.

This happened to this book, and book 6, leading to there being 2 unpublished Artworks for books 6 and 7. You can find these unused covers towards the end of this book.

Original cover below.

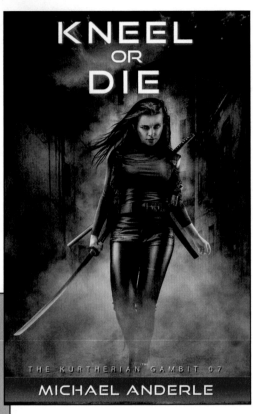

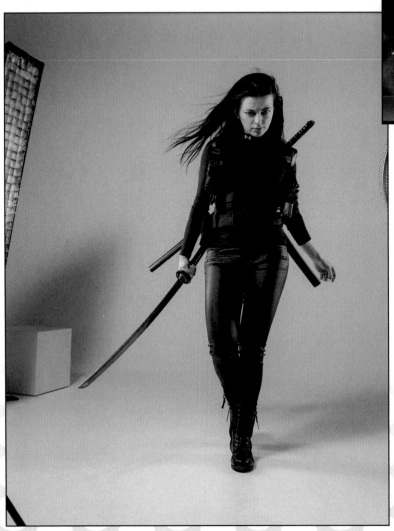

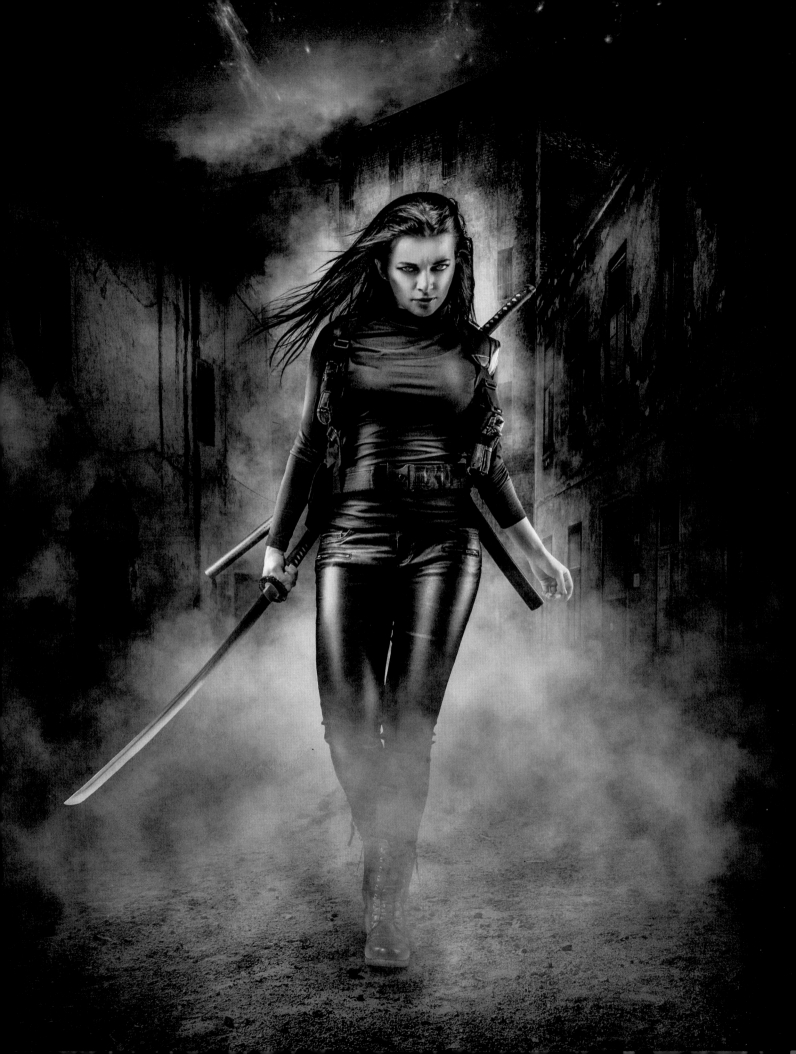

THE KURTHERIAN GAMBIT

Book 18 - Might Makes Right

After book 7, Michael moved me onto other projects, as he wanted to try having Spaceships and such on the covers instead of Bethany Anne. But, I would soon return to the series with this, book 18.

The background was created by another Artist, Jeff Brown, and I was asked to put Bethany Anne into the scene. The finall cover was adjusted slightly from what you see on the right by Jeff, but this is what I handed back.

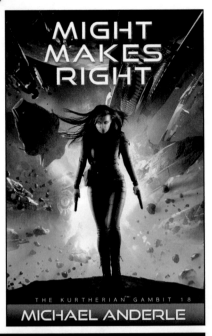

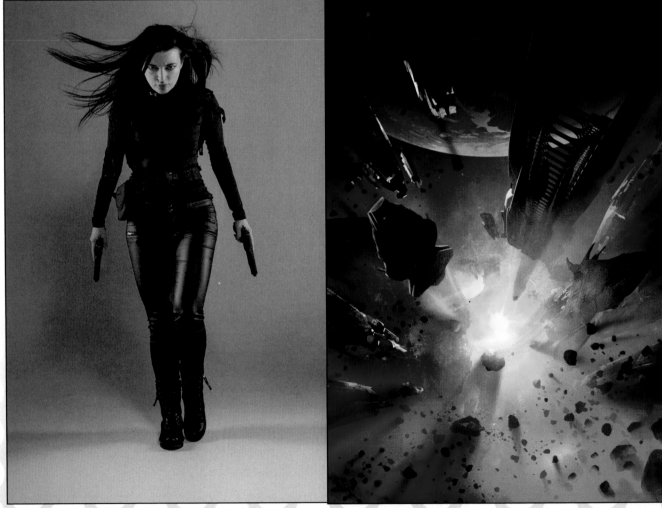

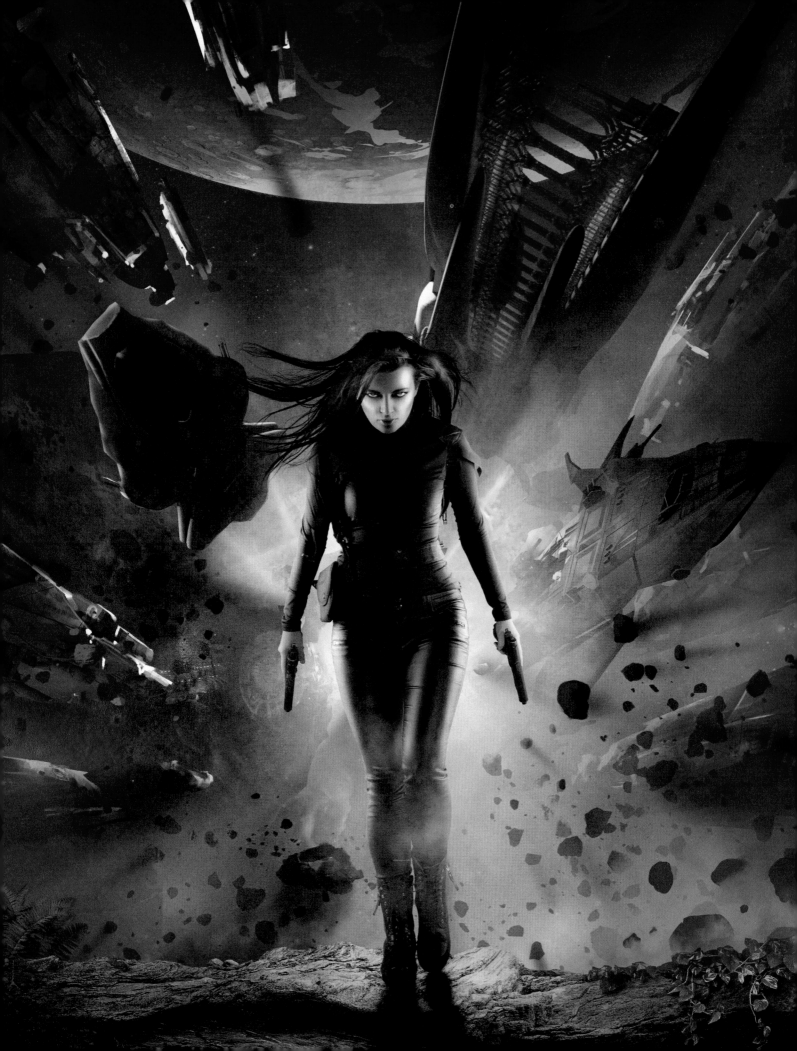

THE KURTHERIAN GAMBIT

BOOK 19 AHEAD FULL

For Ahead Full, Bethany Anne develops the alternate personality of Baba Yaga, allowing her to move about undetected. Michael had a clear idea of what she looked like, and I had to create it.

Turning black hair white is always tricky, and ultimately usually means a lot of painting, and this was no different.

Again, I didn't create the background for this one.

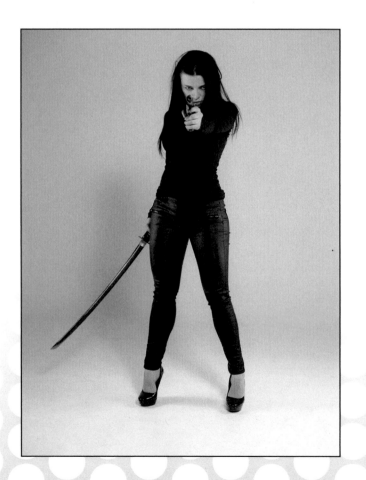

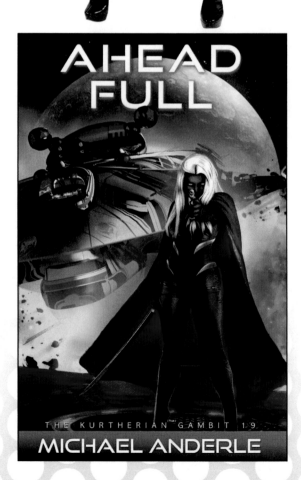

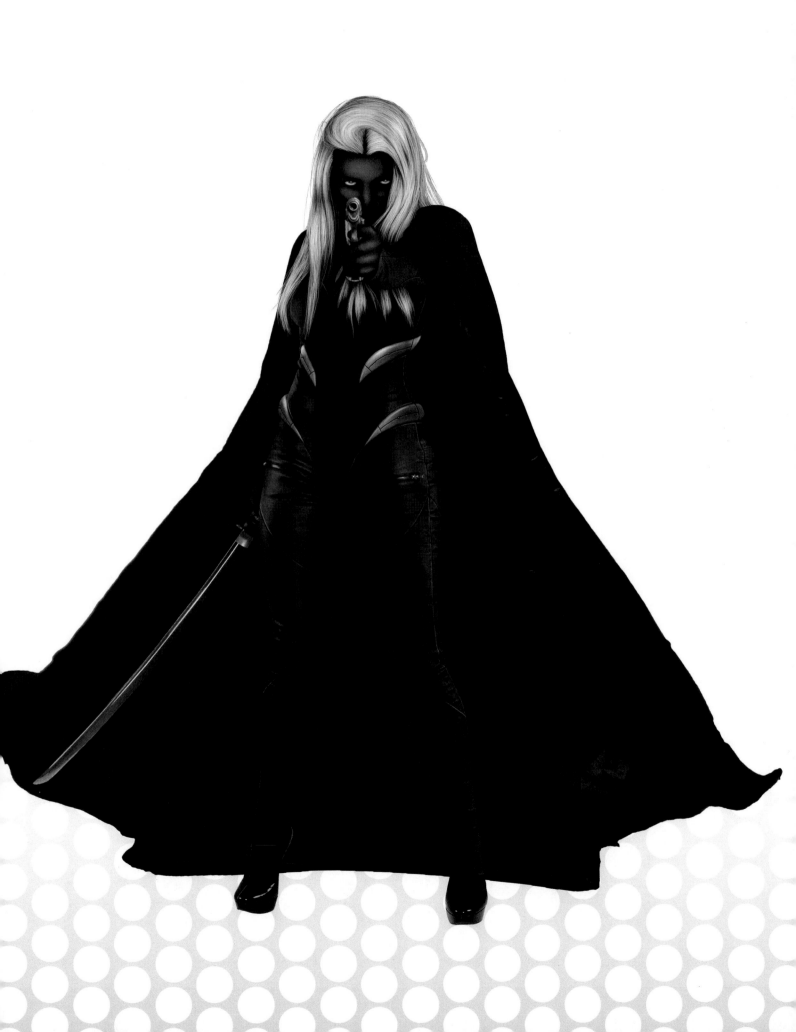

THE KURTHERIAN GAMBIT
BOOK 20 - CAPTURE DEATH

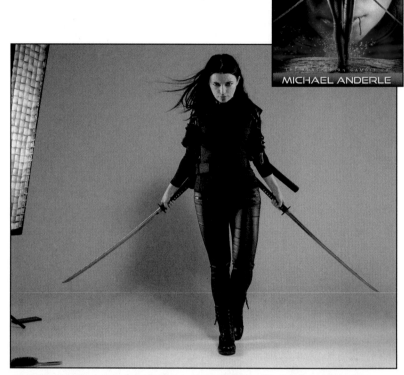

One of my favourite Bethany Anne Covers. The idea was to show the two sides to her personality at this time, Bethany Anne, and Baba Yaga.

Getting the hair to look right was a challenge, but I think I made it work.

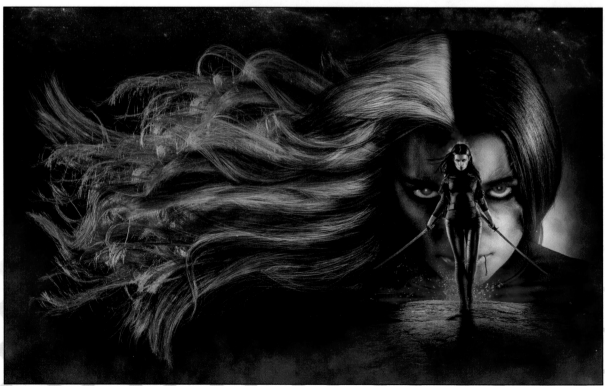

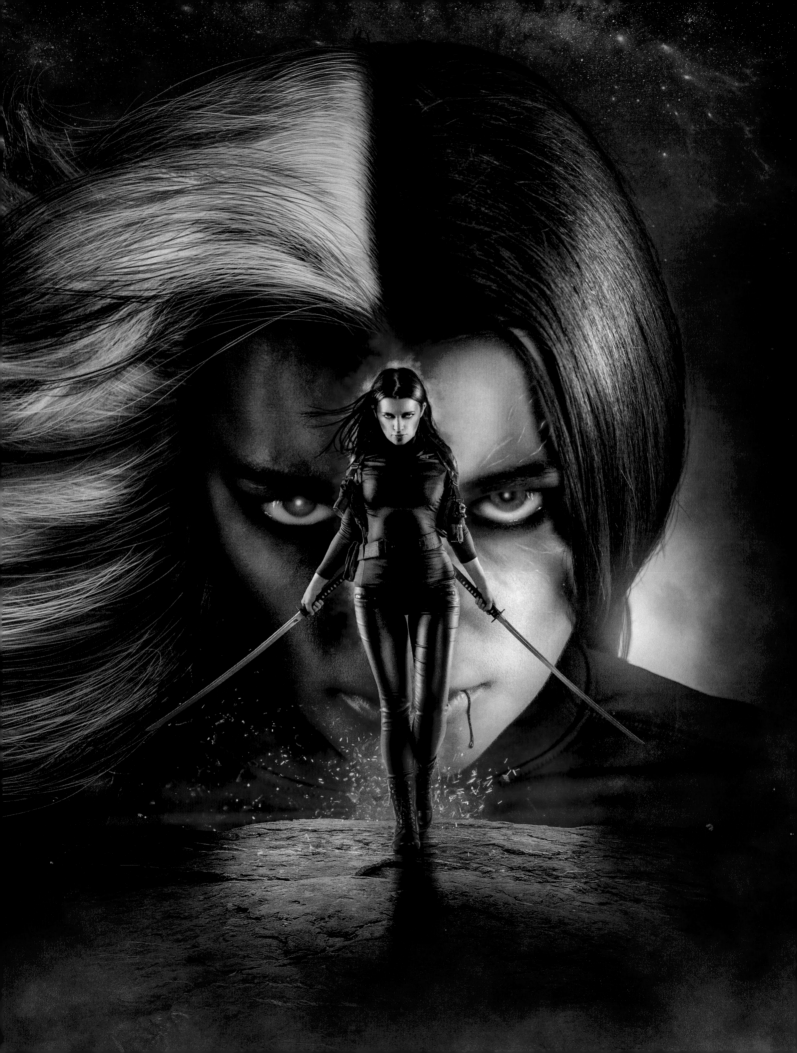

THE KURTHERIAN GAMBIT
Book 21 - Life Goes On

Finding photos that fit a stock photo, and then making them fit together is certainly one of the more entertaining parts of what I do.

Luckily I had some shots of Helen with her foot up on a chair for this one.

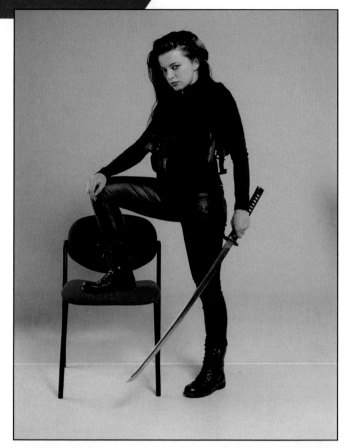

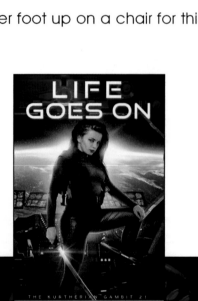

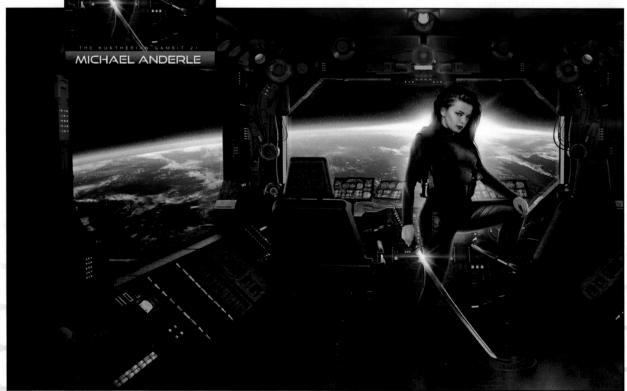

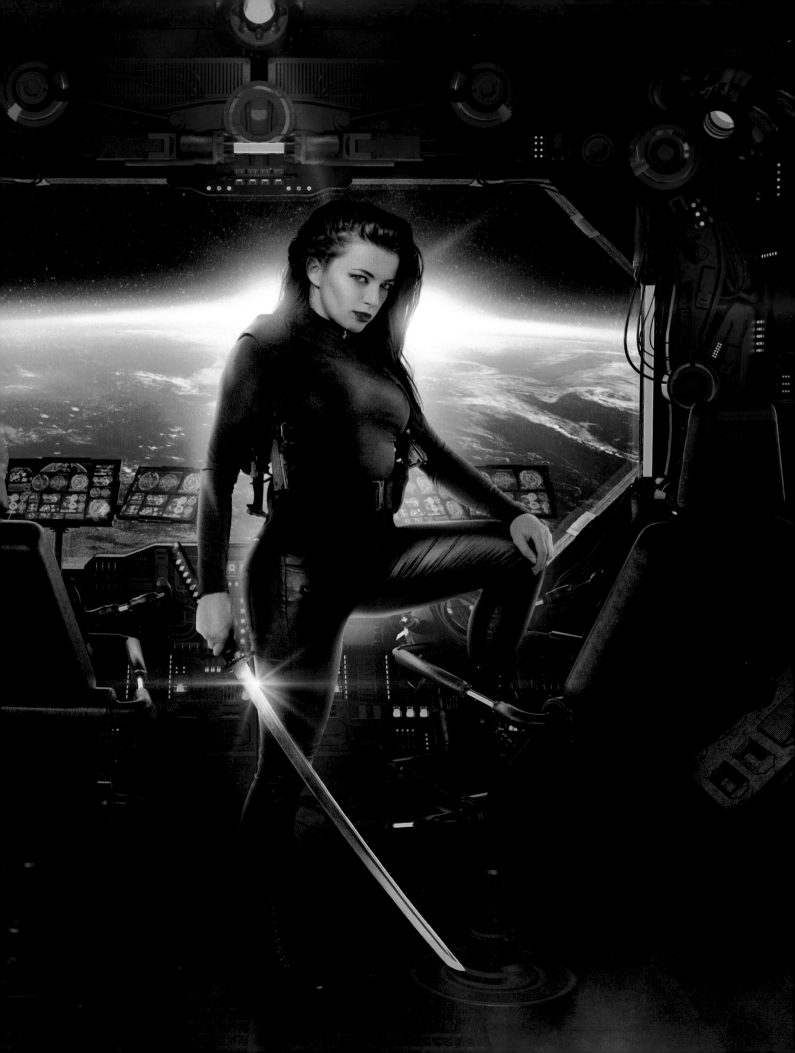

SHORT STORIES
You Dont Touch John's Cousin

I don't know who John is, or who his cousin is, but, if it means I have to deal with these two, I'll keep well away! :-)

Seriously though, this was fun. This shot of Helen fits right in with this stock image. I don't think you'd know they were shot separately, by two different people.

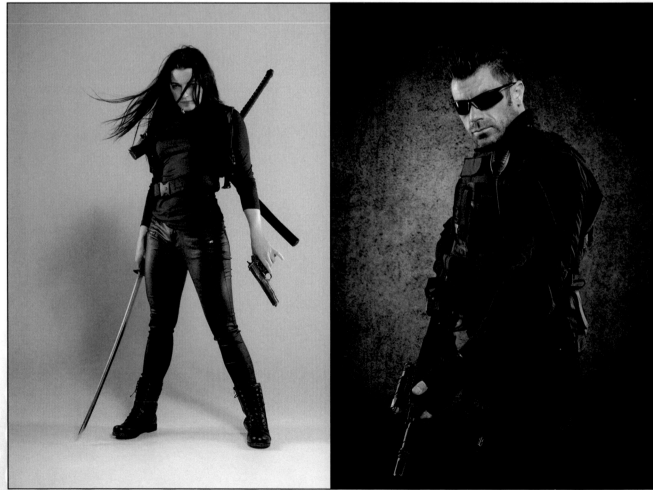

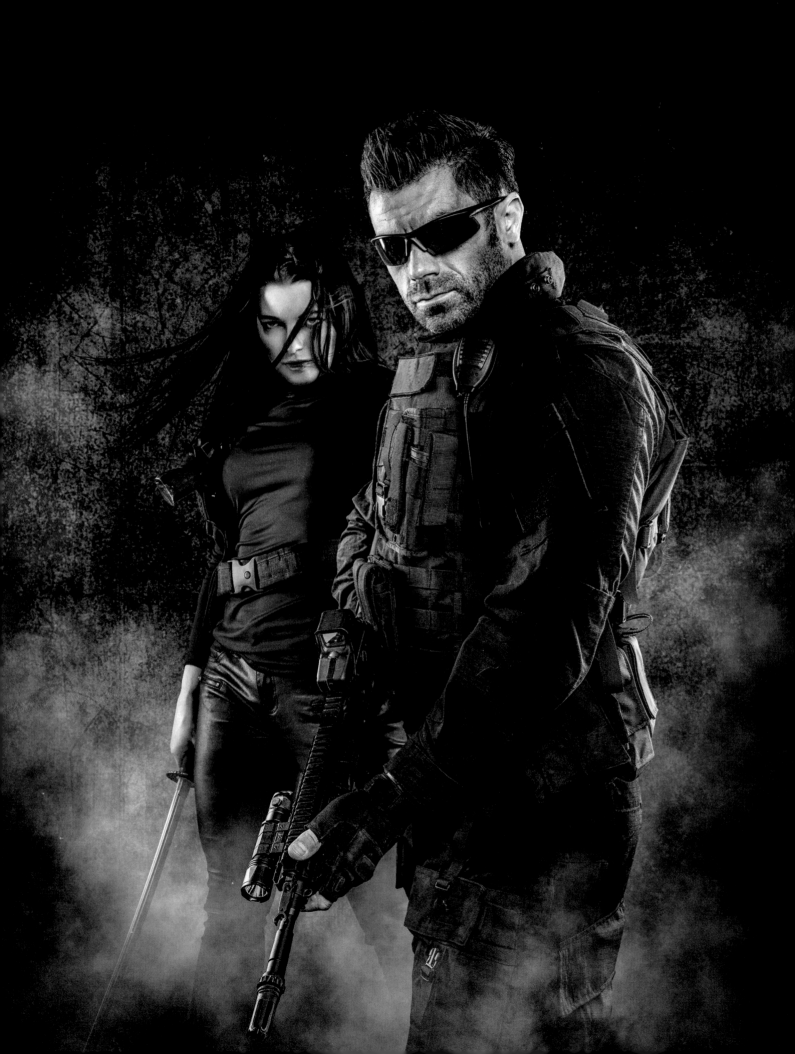

SHORT STORIES
BITCH'S NIGHT OUT

The dramatic lighting on the two soldiers meant I needed side lighting on BA as well, and there were only a few that were shot that way.

But, at least I had some.

This is also an example of swapping the head from one shot to another to get the finished image.

In the end, I was rather pleased with this.

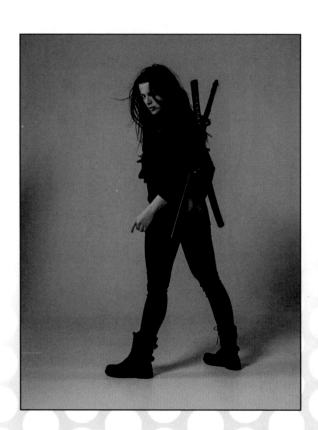

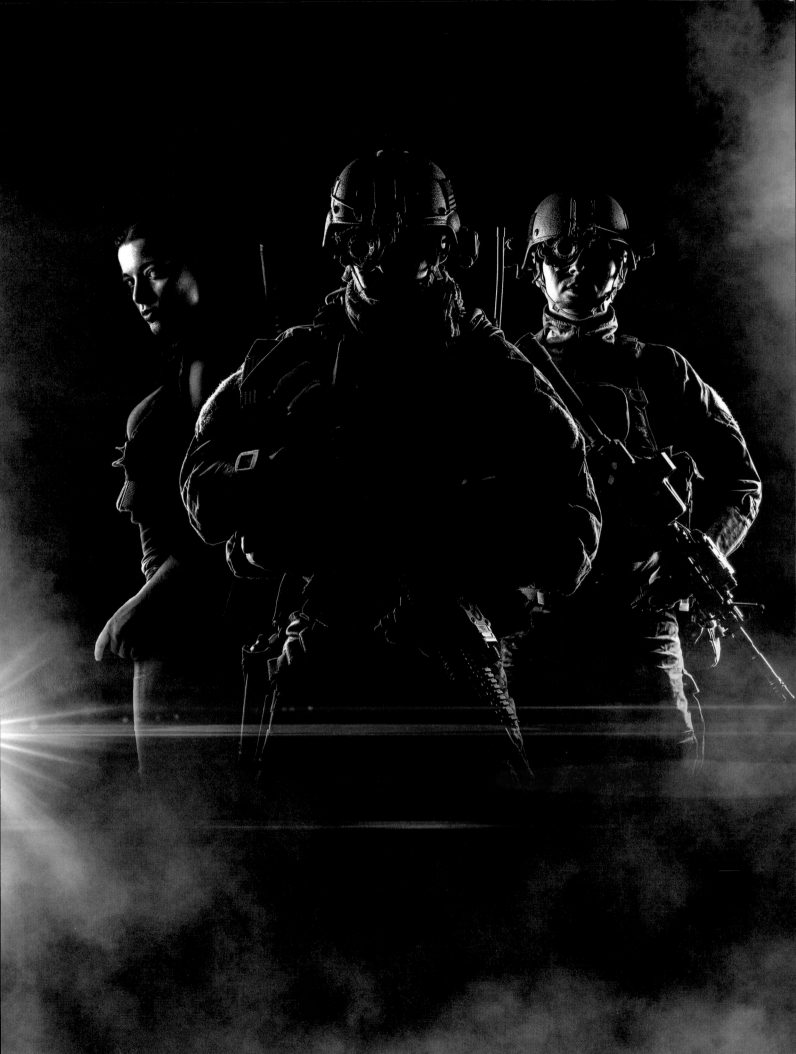

Some edits are simple, with just a few images to mix together, while others are much more complicated.

This cover was created from a collection of several stock images, which you can see to the right of this text.

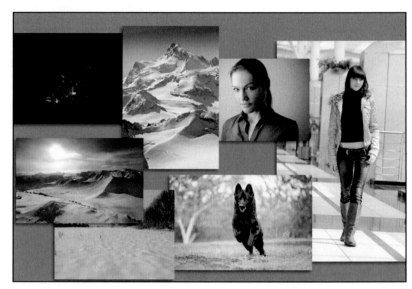

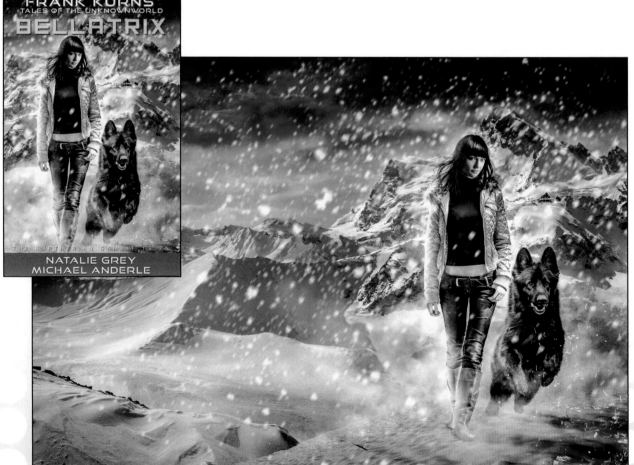

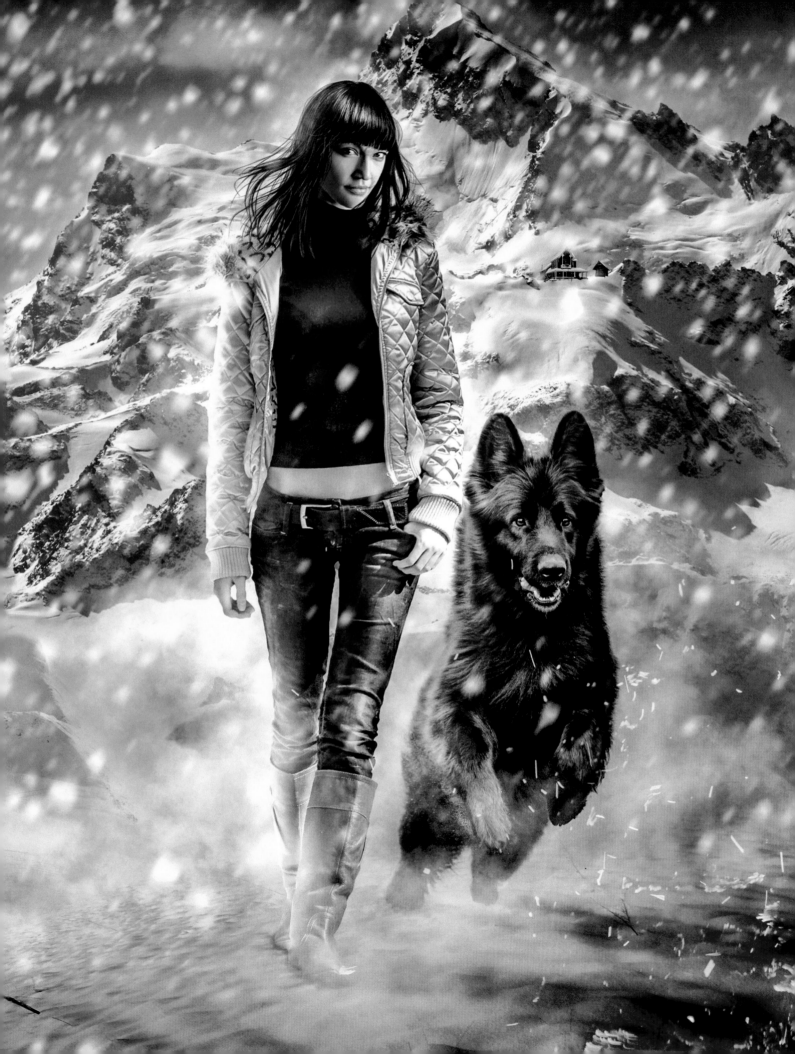

TERRY HENRY WALTON

Book 1 - Nomad Found

After working with Michael Anderle on the Bethany Anne Covers, it was fun to take what I'd learnt from that experience, and apply it to the Nomad covers.

Initially, the first 3 covers were made entirely from stock, which you can see below, which is cheaper to do, and given Craig didn't know if the series would do well, made sense.

But, when it was clear the series would continue, the choice was made to do a shoot.

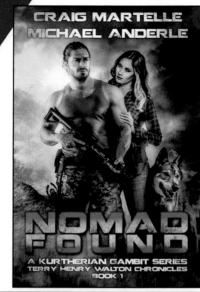

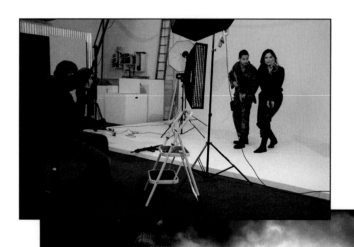

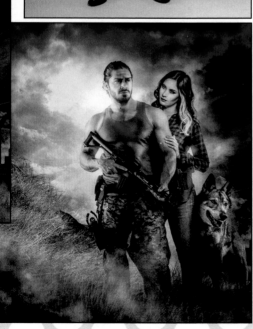

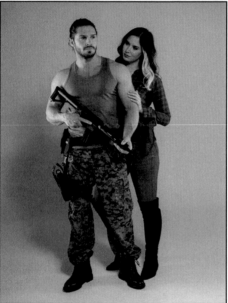

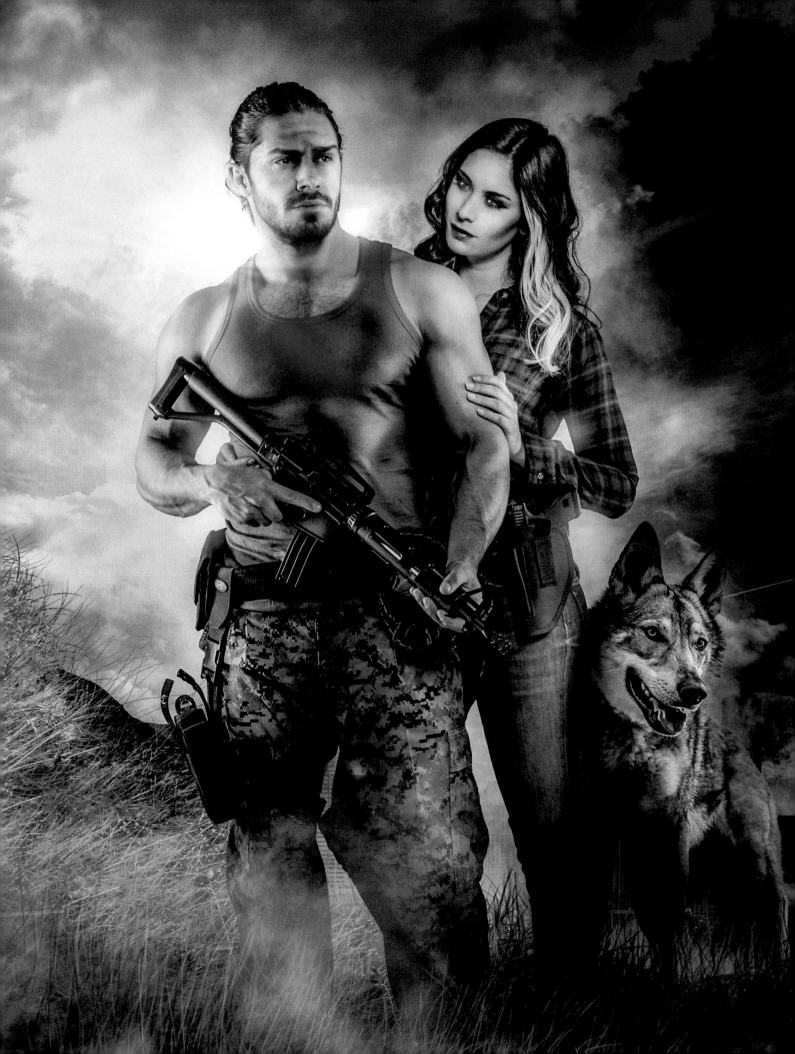

TERRY HENRY WALTON
BOOK 2 - NOMAD REDEEMED

The shoot went really well, and within the Kurtherian Gambit, is the shoot I have created the most covers from. The total, with the Omnibus editions, sits at 19 published covers I think.

Props are an invaluable part of a shoot, but, they don't always work as well as you'd like. Such as Terry's whip, which I had to replace in Photoshop to make look any good.

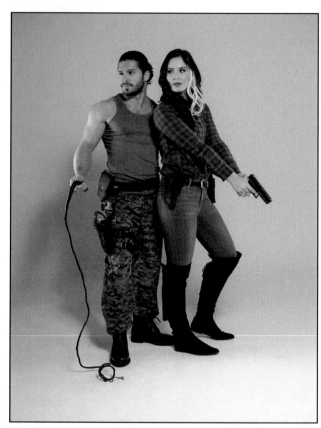

CRAIG MARTELLE
MICHAEL ANDERLE

NOMAD REDEEMED

A KURTHERIAN GAMBIT SERIES
TERRY HENRY WALTON CHRONICLES
BOOK 2

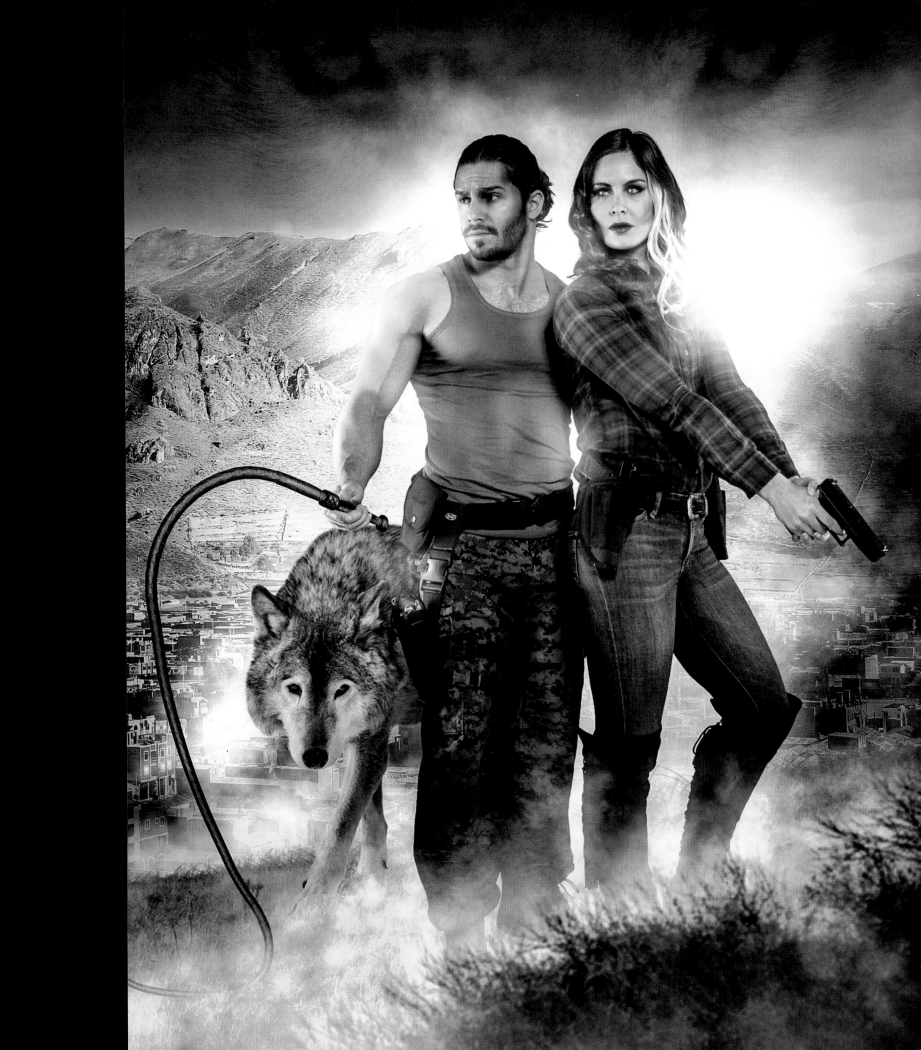

I live in the UK, meaning we don't have great access to guns. Most models that I shoot with have never held one, let alone shot one. So, I always end up running through some basic pointers about how they should be held etc. Here we see Terry demonstrating good trigger discipline.

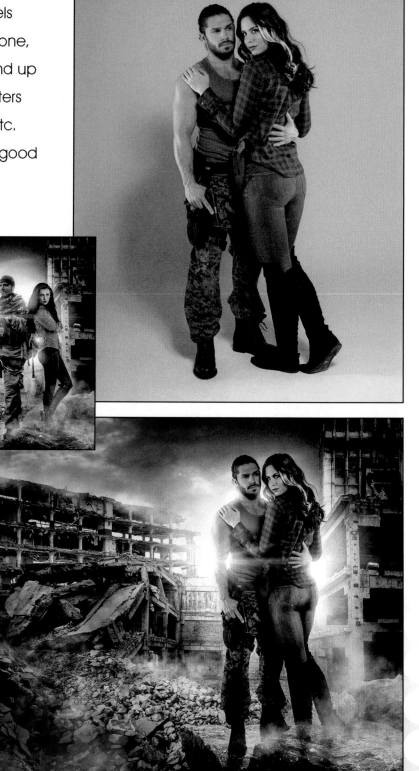

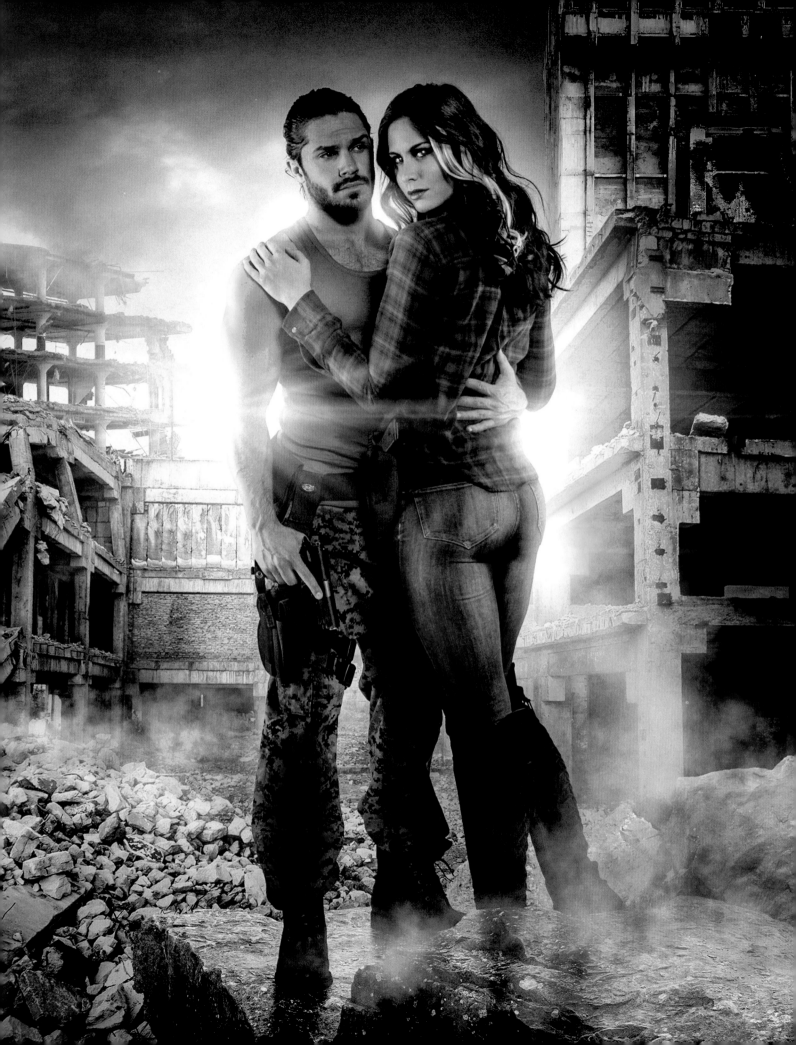

The lack of guns in the UK, means that generally I buy in BB (Airsoft) replicas for the shoots. They're usually good enough to pass muster in a shoot and look real enough for most people.

However, eagle eyed readers have pointed out that there are tell-tale signs that the guns aren't real. It's not something that bothers me. And, to be honest, even if I could get real guns for a shoot, I probably wouldn't.

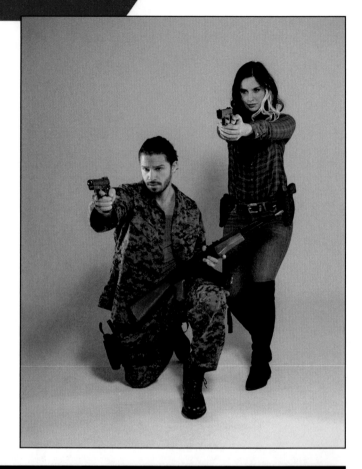

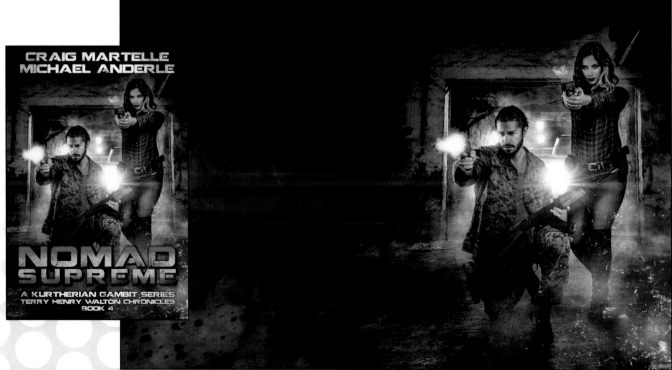

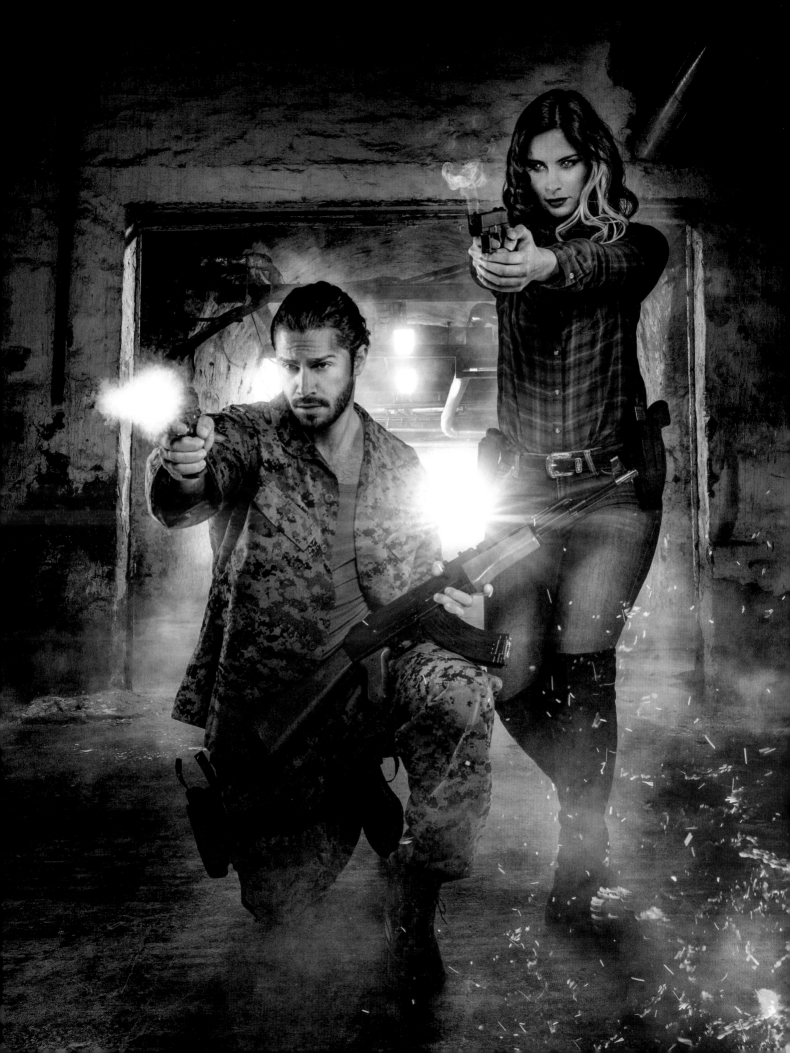

TERRY HENRY WALTON

BOOK 5 - NOMAD'S FURY

While the model for Terry generally was good at his trigger discipline Holly, the model for Char, wasn't as good at remembering. You can see that both forgot it in this shot.

Luckily, Craig used this in his books, making it something that Char did in the

stories.

I love it when the Author takes something in a cover I've shot, and incorporates it into the plot.

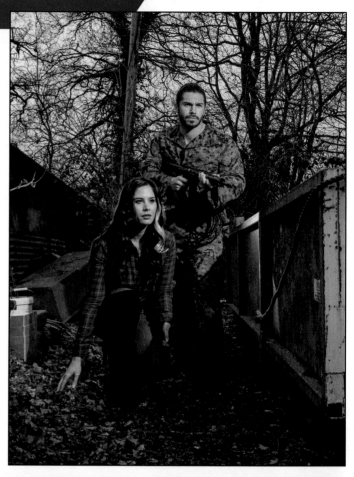

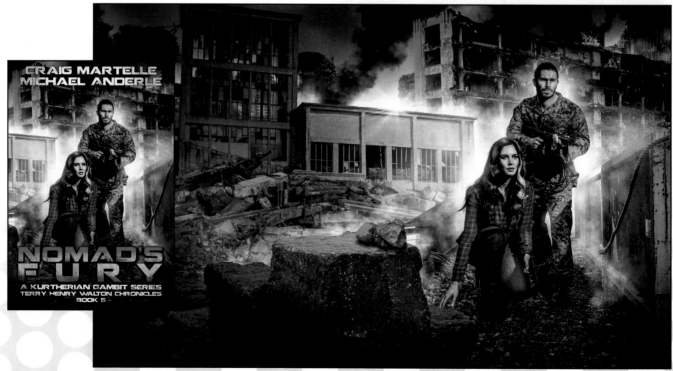

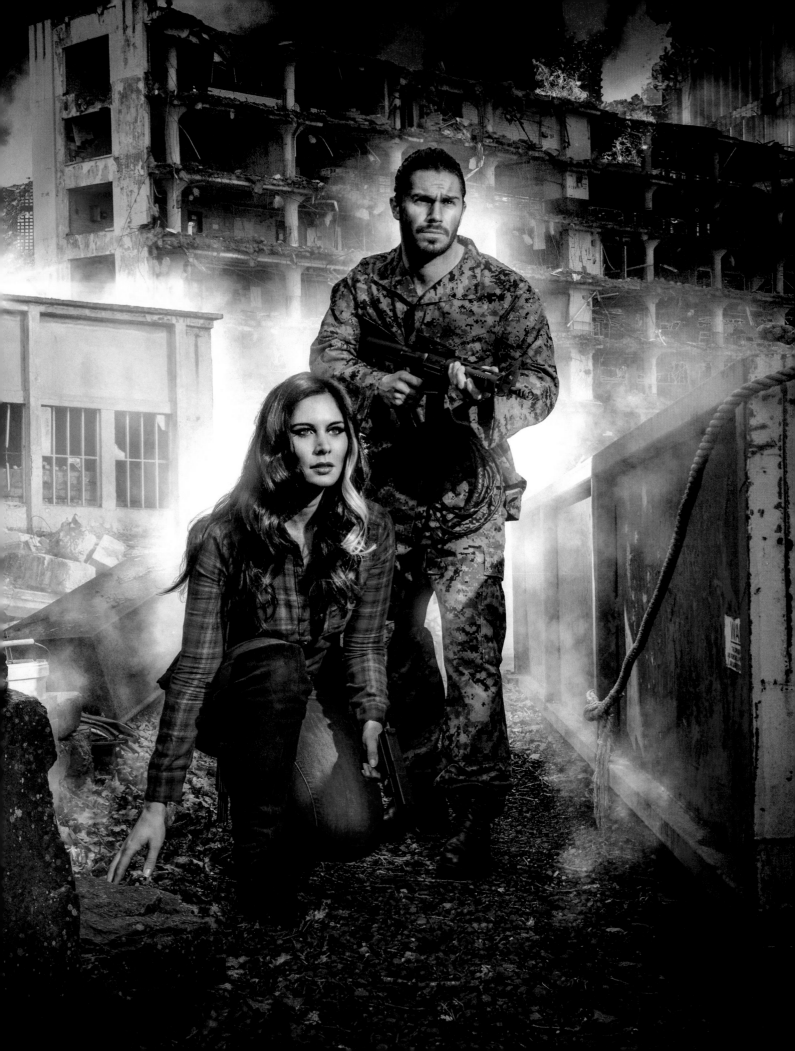

Most of my cover shoots take place entirely inside, where I shoot the models against a white or grey background.

But, there were a couple of spots outside the studio where I shot these that seemed to work with the general Post - Apocalyptic feel of the books.

So, we finished the day with a few outside shots as well.

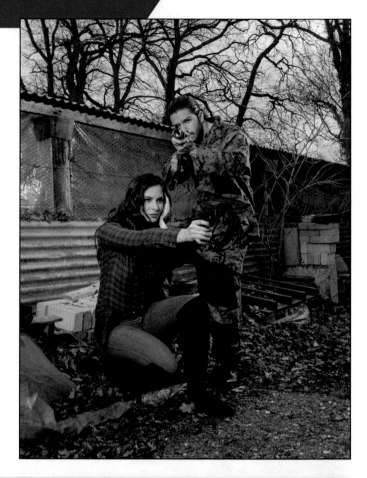

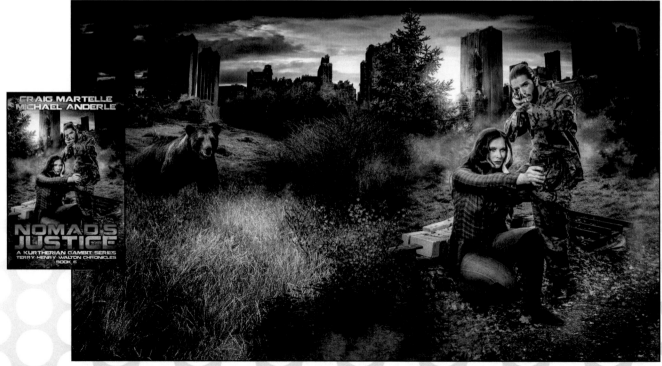

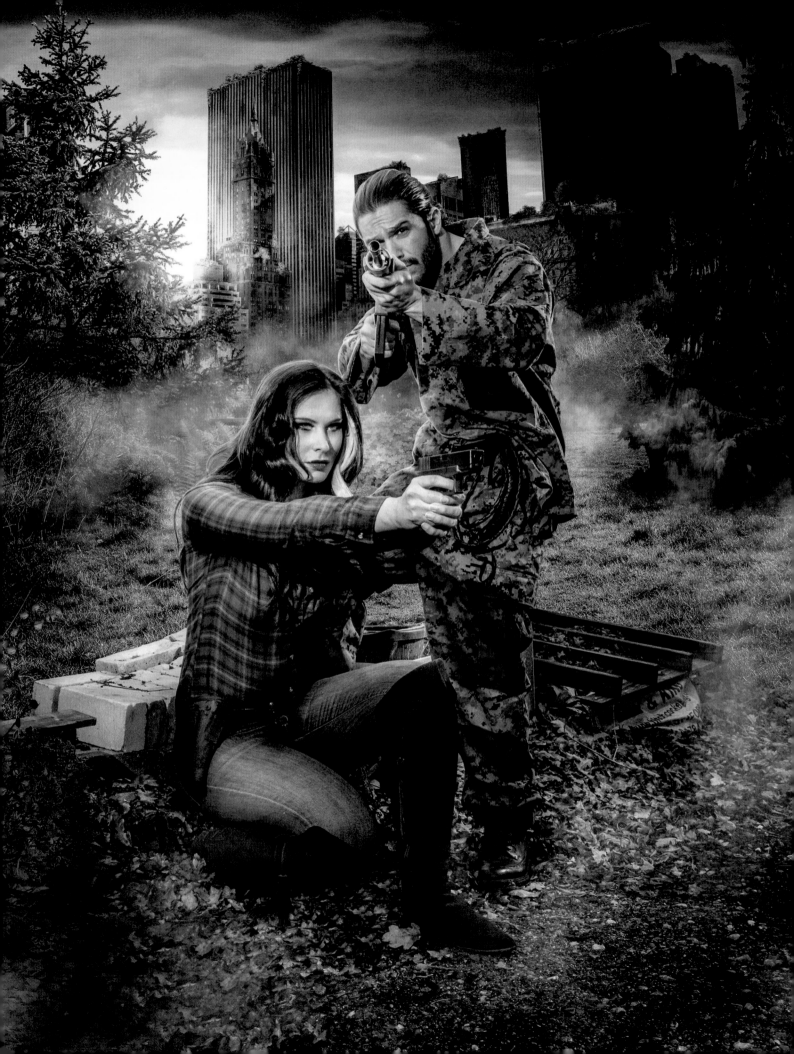

TERRY HENRY WALTON

BOOK 7 - NOMAD AVENGED

I enjoyed the format change of this one.

Having Char up front and close to the camera works really well. I'm happy with the choice of shot for the tiger as well.

It's one of my favourite images in this series.

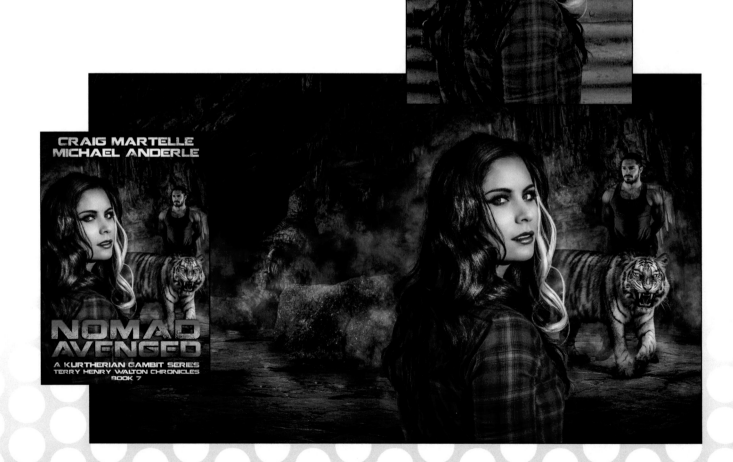

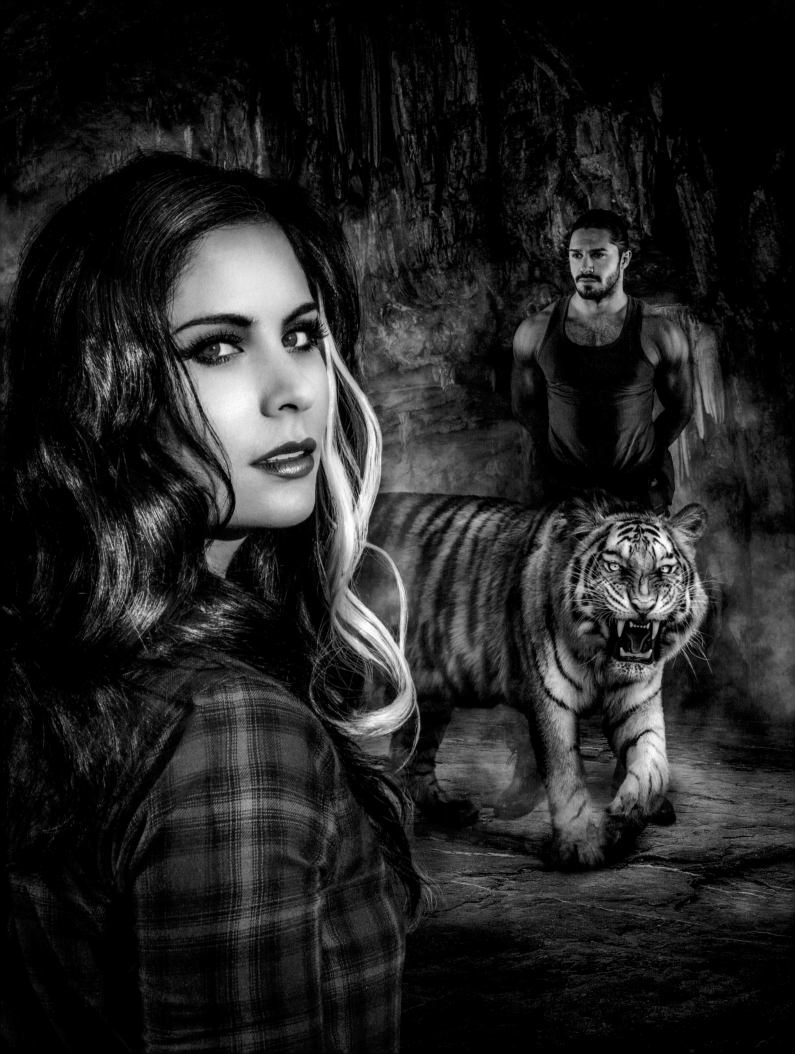

Even when shooting two models, who I know are a couple in the books, it's important to shoot them separately as well, even if they will be in a pair shot for the cover.

It allows for more freedom in positioning to them relative to each other and makes lighting them easier as you don't get shadows cast on them.

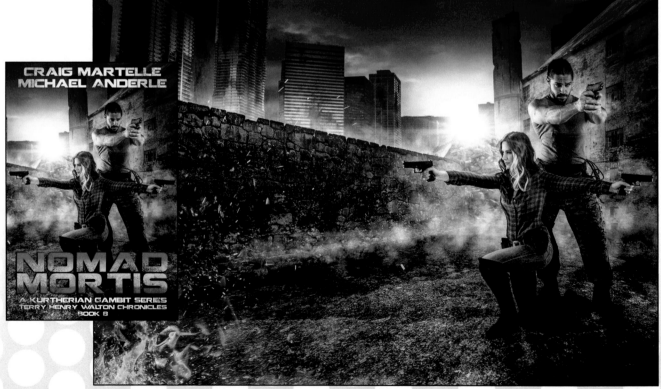

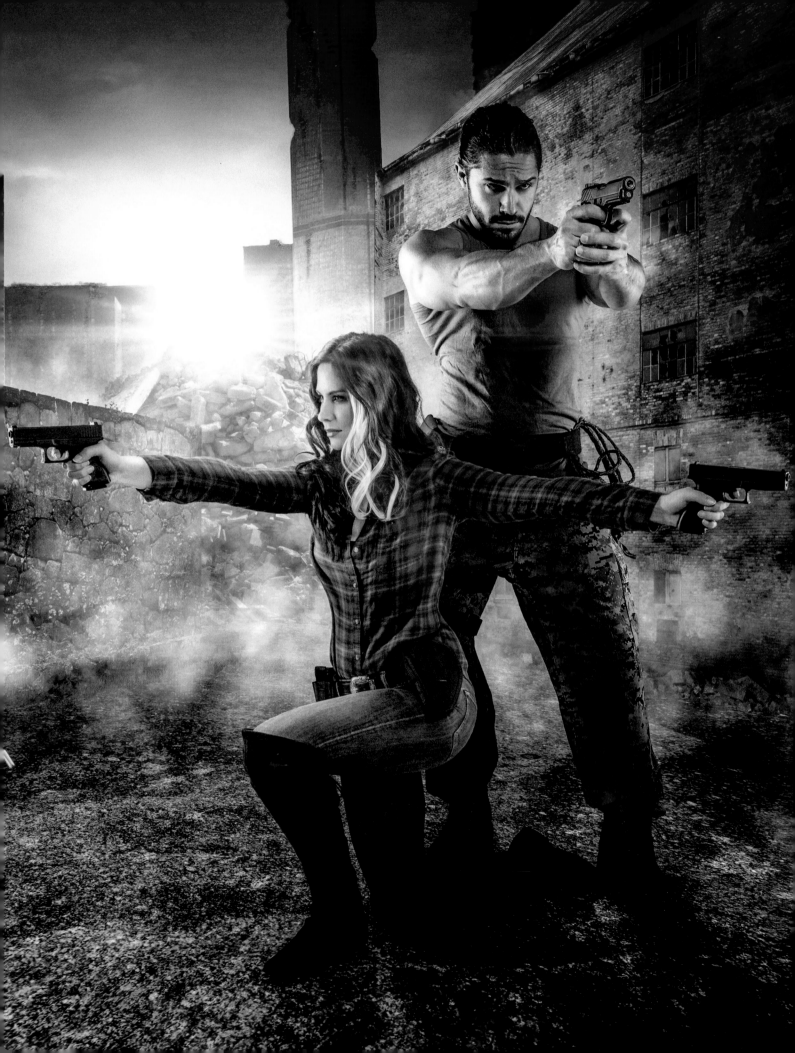

This is another example of the cover influencing the narrative. In another series, set in the same world, but, later in the timeline, it's established that the Eiffel Tower has had the top of it knocked off.

I created this cover as Craig asked for a European monument in the background. On seeing this, Craig chose to have Terry be the one to destroy the tower. I loved this detail!

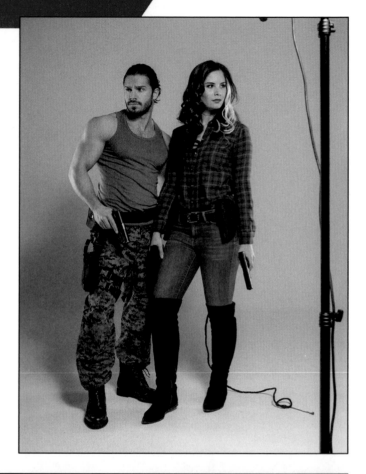

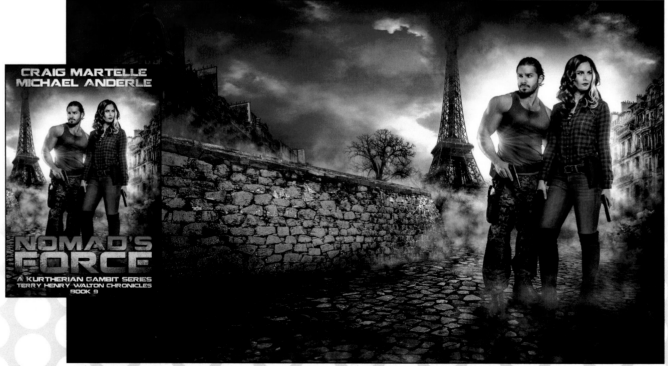

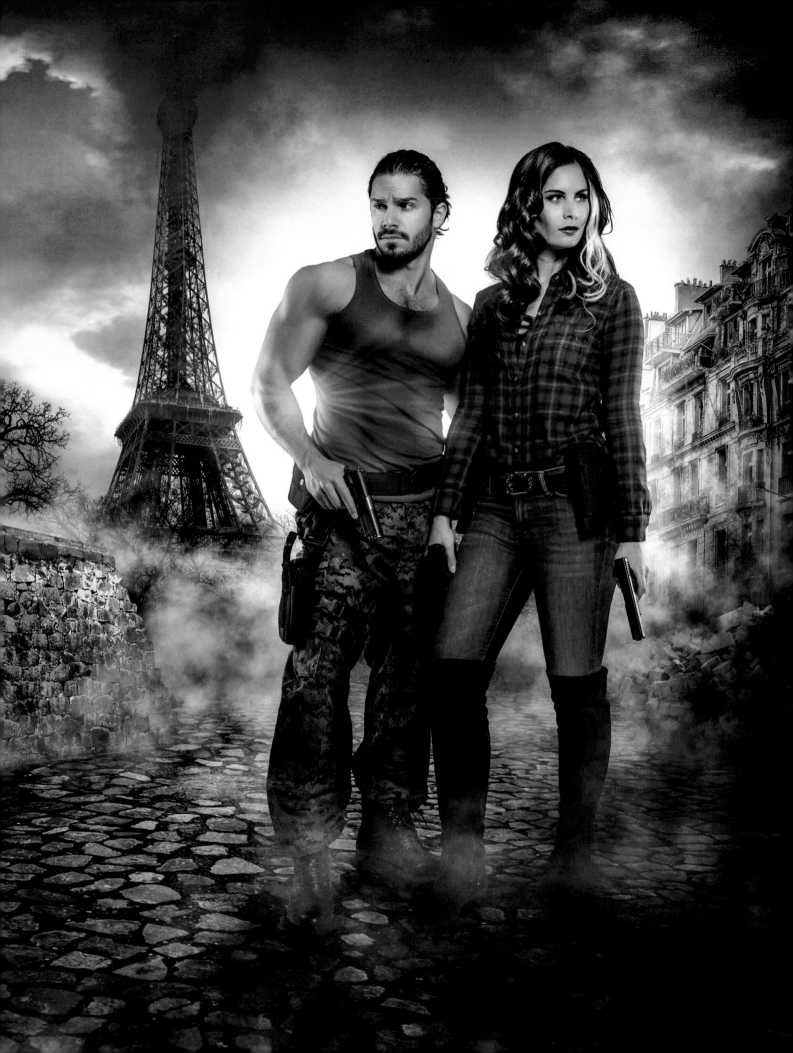

A more tender shot of Terry and his wife Char.

Getting models to be romantic or intimate during a shoot doesn't always work, and, some models will refuse to do even something like a hug with a model of the opposite sex. So, it's always wise to make sure your chosen models are happy to do that kind of work.

And then you have to deal with the endless giggling that results from poses like this. :-D

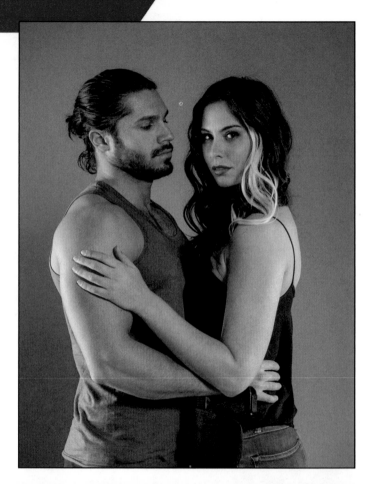

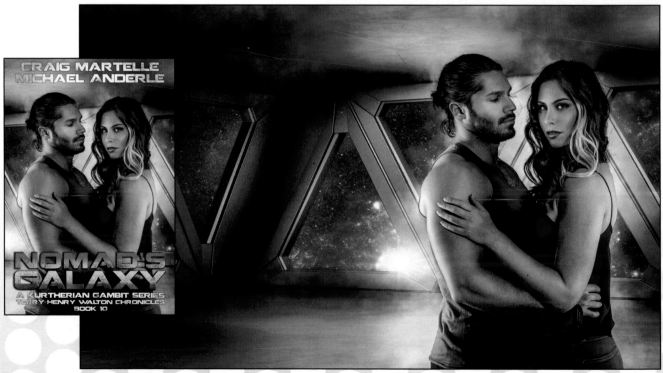

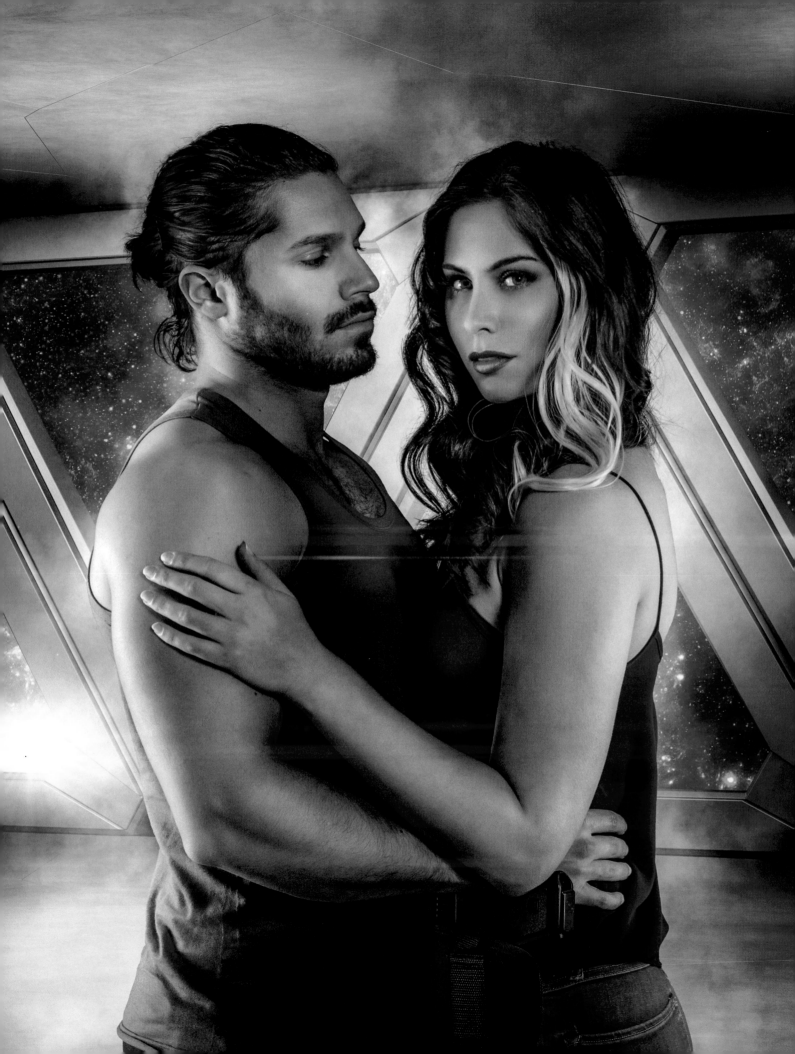

TERRY HENRY WALTON

NOMAD'S JOURNAL

In addition to the omnibus editions, Craig needed a cover for a collection of short stories and requested a change in style. Based on the reference images that Craig supplied, I created this.

I love it, but that whip still bugs me! :-)

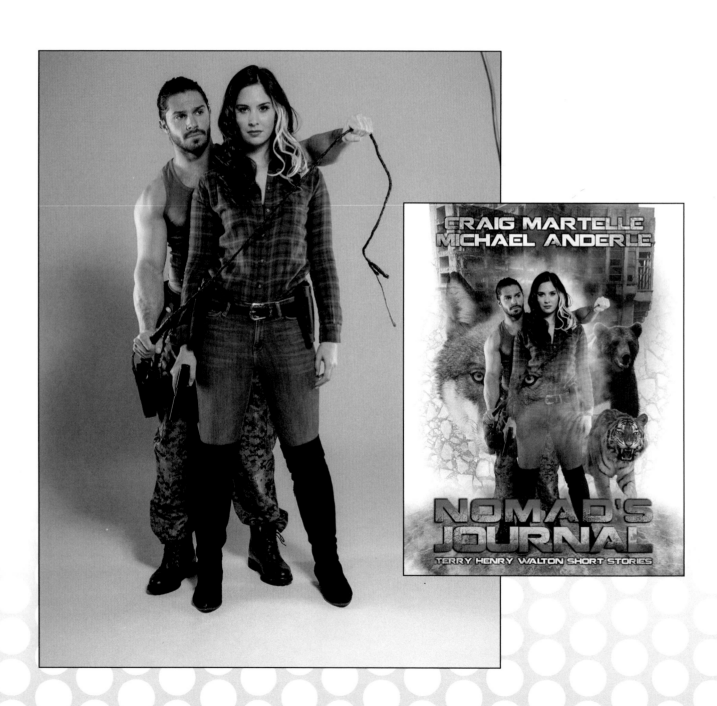

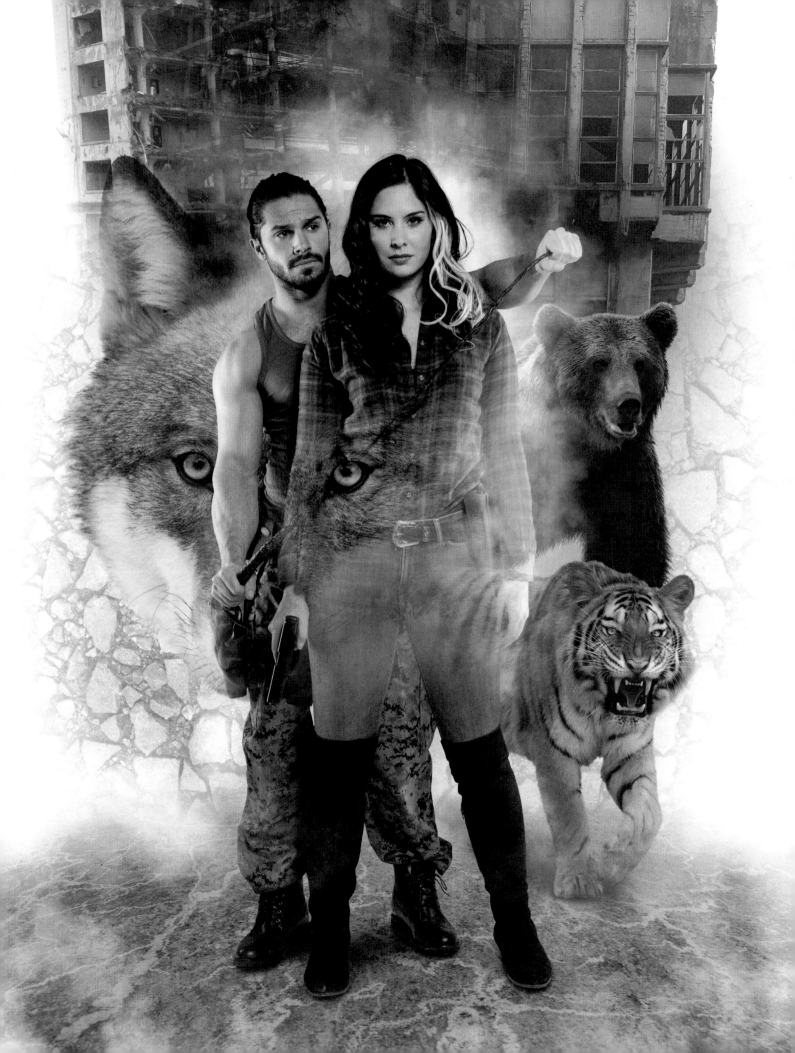

THE ASCENSION MYTH

Awakened

Within the modelling world, there are a few, well known models, and doing these covers has allowed me to work with models I might not have otherwise had the chance to work with.

Romanie, the model for the Ascension Myth, was one such model. We've worked together a few times now, and she's great!

Fun, easy to work with, knows her stuff, and very professional.

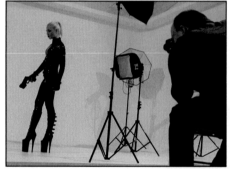

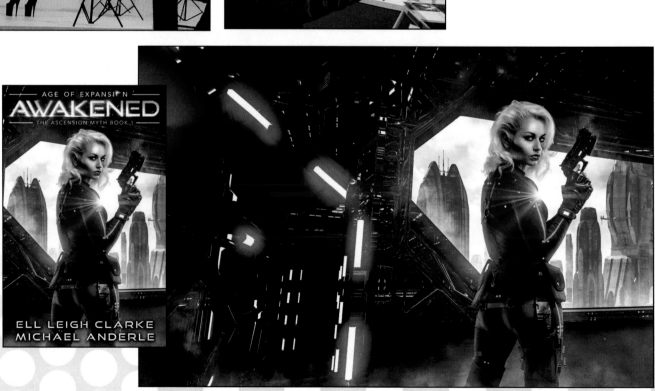

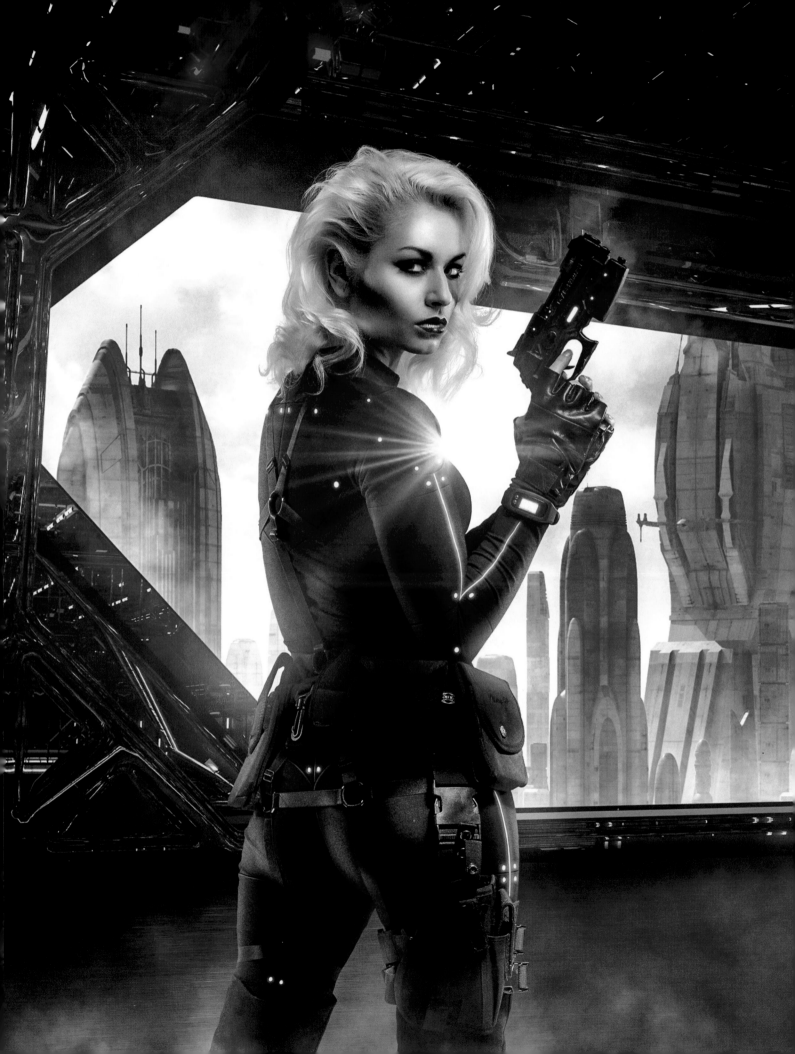

THE ASCENSION MYTH

ACTIVATED

These Ascension Myth covers marks the first time I used 3D in my cover work. The background for book 1, book 2, and the ship on book 3, were all 3D renders.

I use 3D much more these days, and it's creeping into my work more and more.

I don't think it will ever fully replace model shots though, well, not for many years yet. There's just something about a real human face that you can't yet beat.

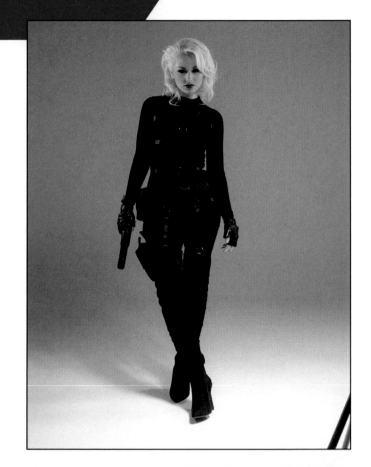

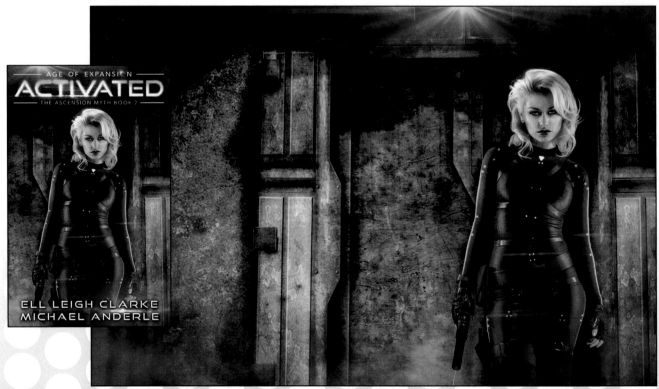

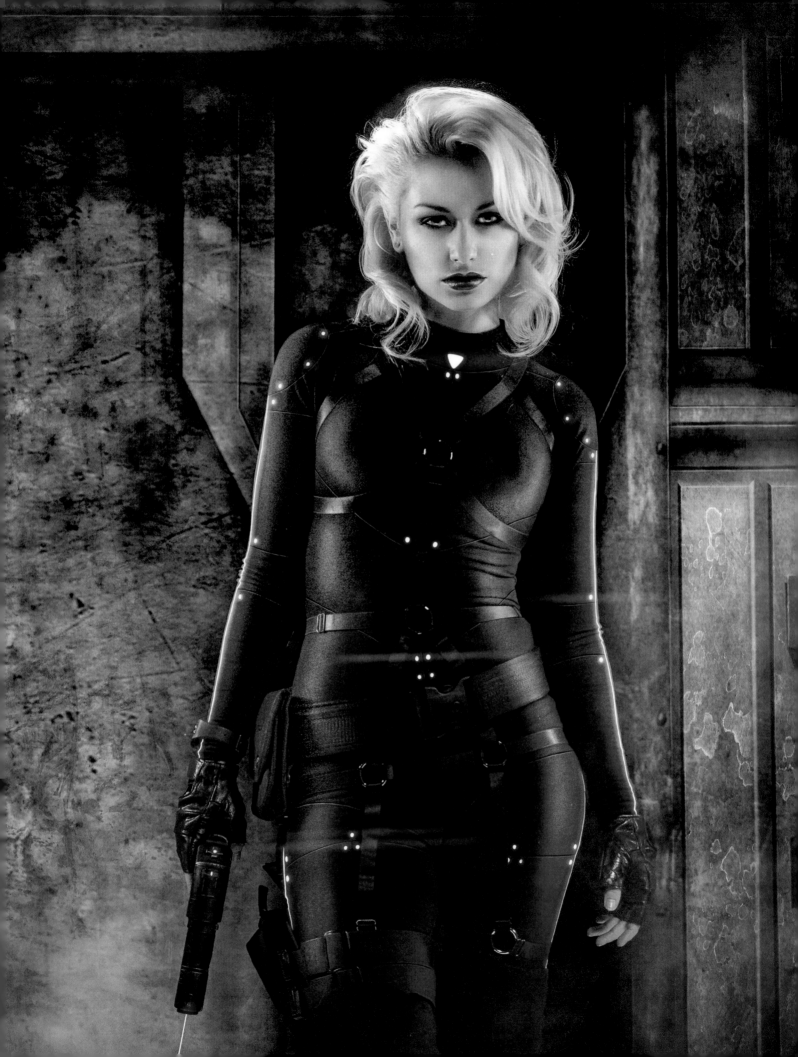

Romanie is well known for her "Fetish" work, where she works with a lot of Latex clothing designers.

Because of this, she was able to bring along one of her black catsuits for the shoot, which have appeared on several of the covers in this series now.

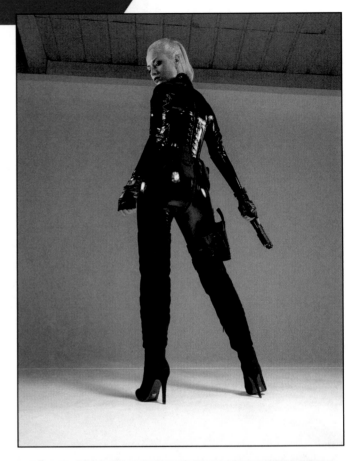

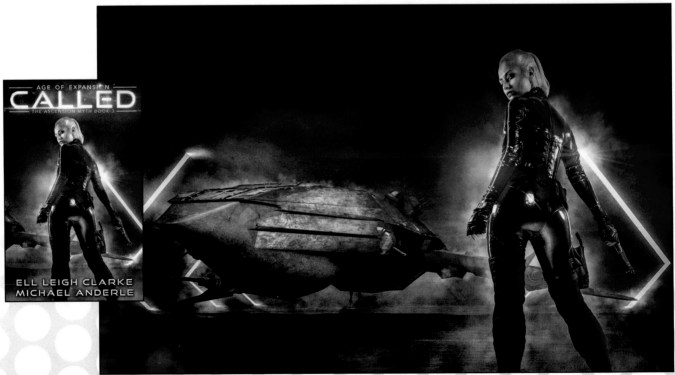

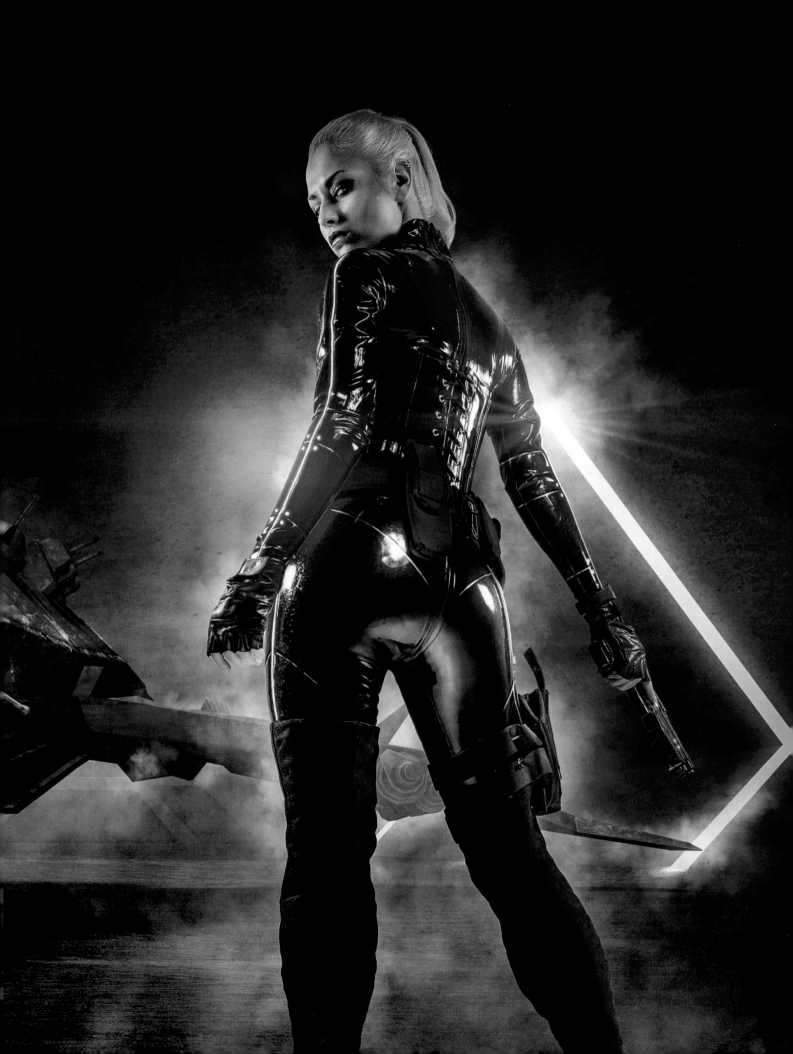

THE ASCENSION MYTH

SANCTIONED

Another example of head swapping, where the pose we wanted didn't have the head position we needed.

Luckily, I'd accidently taken a shot of Romanie between poses, when she was looking down at her sword as she moved.

It turned out to be the perfect shot!

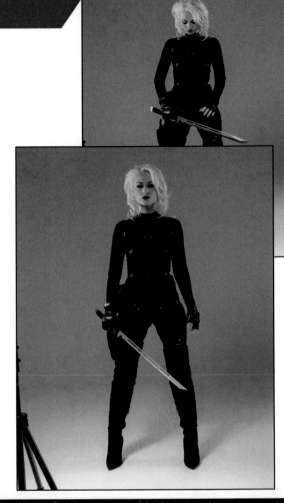

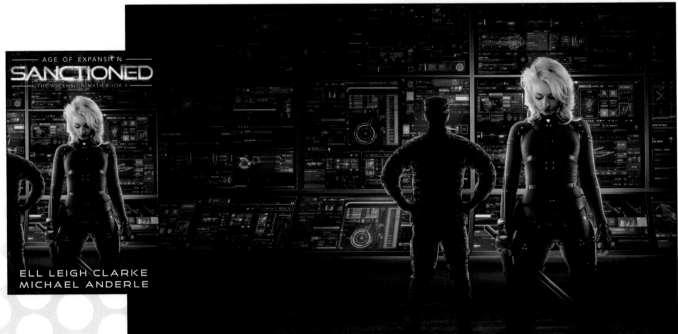

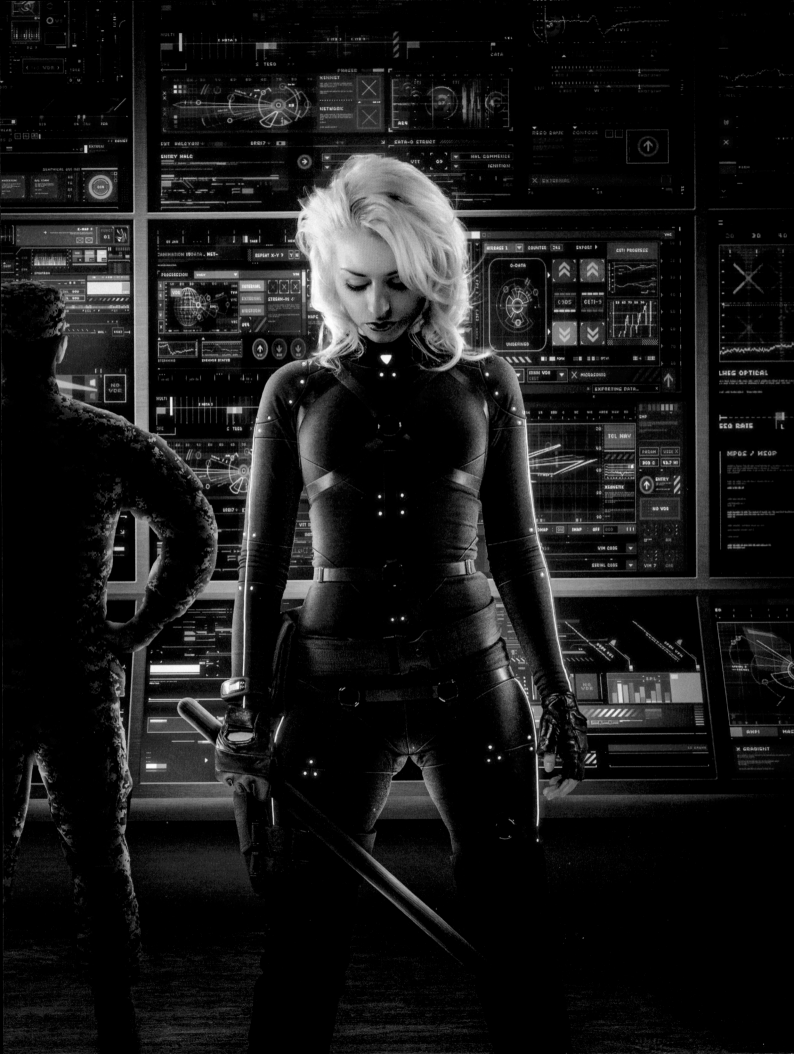

THE ASCENSION MYTH

REBIRTH

These days, when I go away any-where, such as on holiday with the family, I'm always taking photos of rocks and cliffs and the ground and trees etc etc.
I'm sure I look strange doing it, but, it's all for a reason.

The rocks you see on this image, which are meant to be a part of an asteroid, where shot on a few beaches while on vacation.

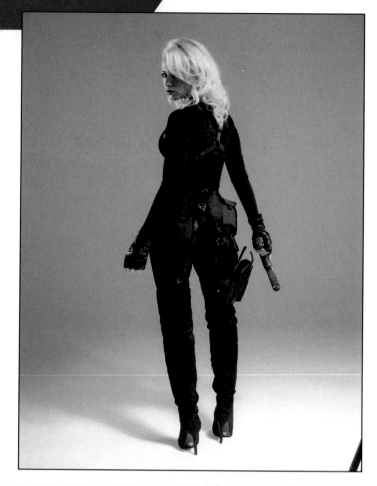

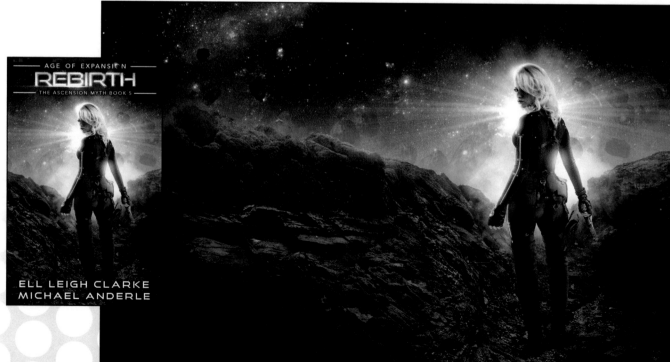

AGE OF EXPANSION
REBIRTH
THE ASCENSION MYTH BOOK 5

ELL LEIGH CLARKE
MICHAEL ANDERLE

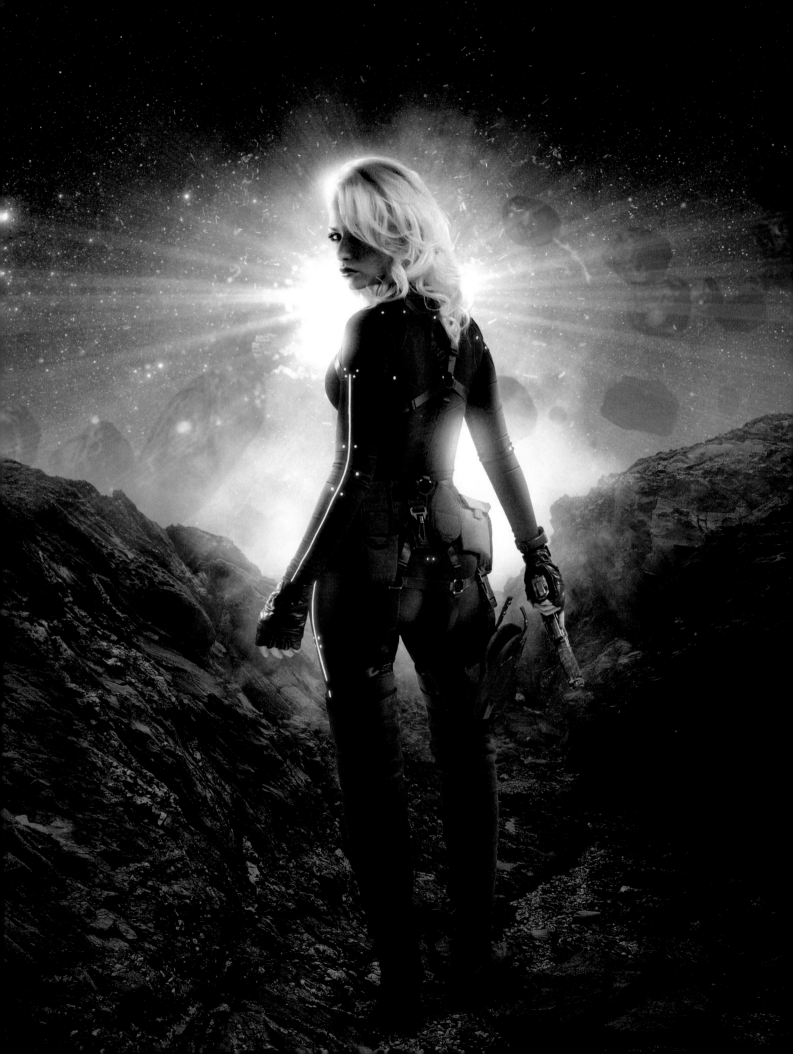

THE ASCENSION MYTH

RETRIBUTION

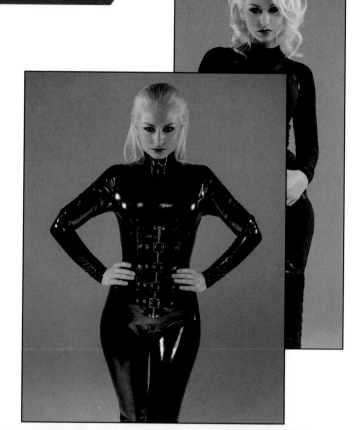

Another example of head swapping.

This is no longer the cover to Retribution and was the last cover I did in this series. It was fun while it lasted, but Michael needed me to work on other things.

But, such as the nature of Indie publishing. Covers can be changed very quickly as needed.

It was fun while it lasted.

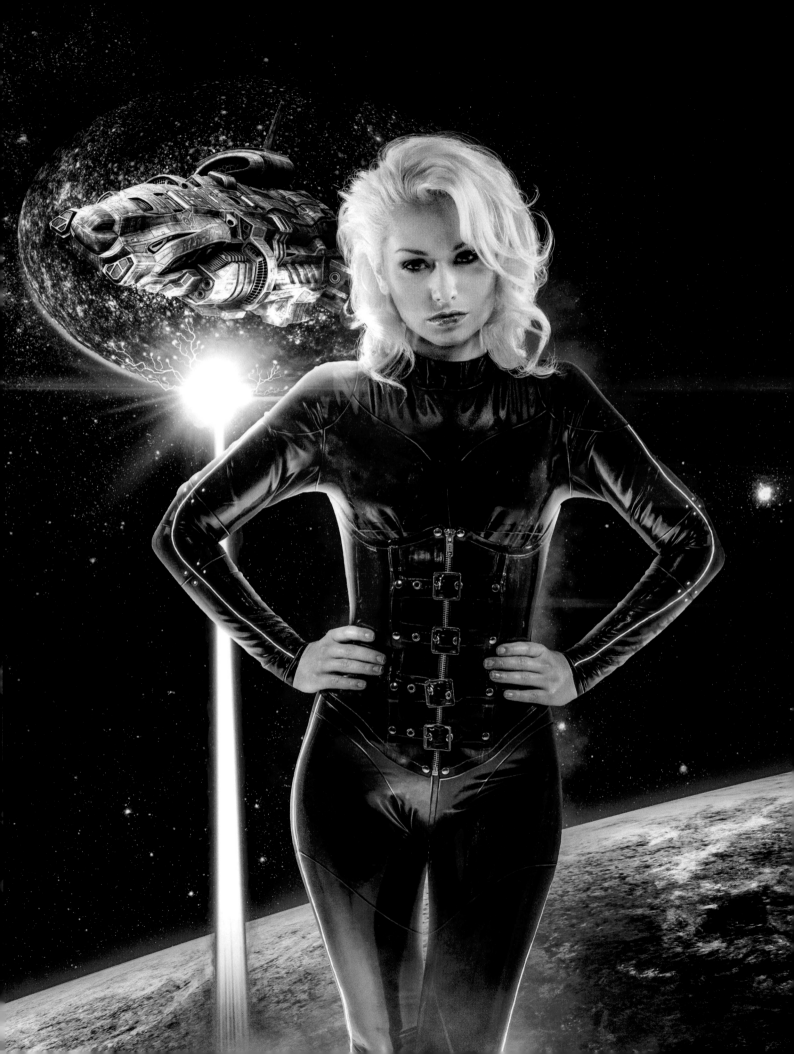

BAD COMPANY

GATEWAY TO THE UNIVERSE

With Michael's publishing empire grow-
ing, and more books coming out,
mode shoots needed doing and more
covers.

Bad Company was the continuing ad-
ventures of Terry and Char. The girl in
the background is Valerie.

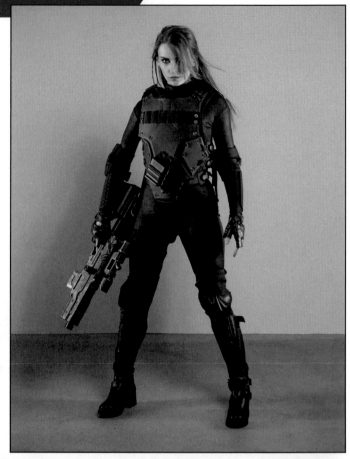

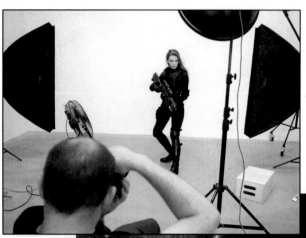

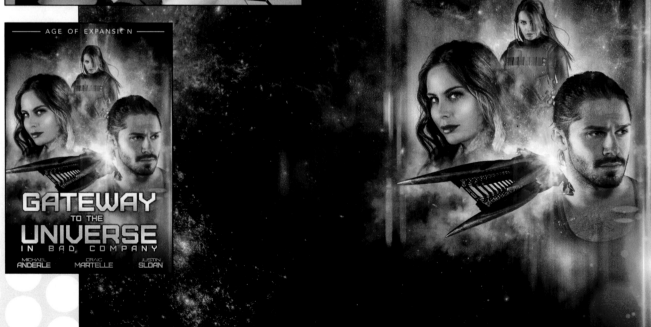

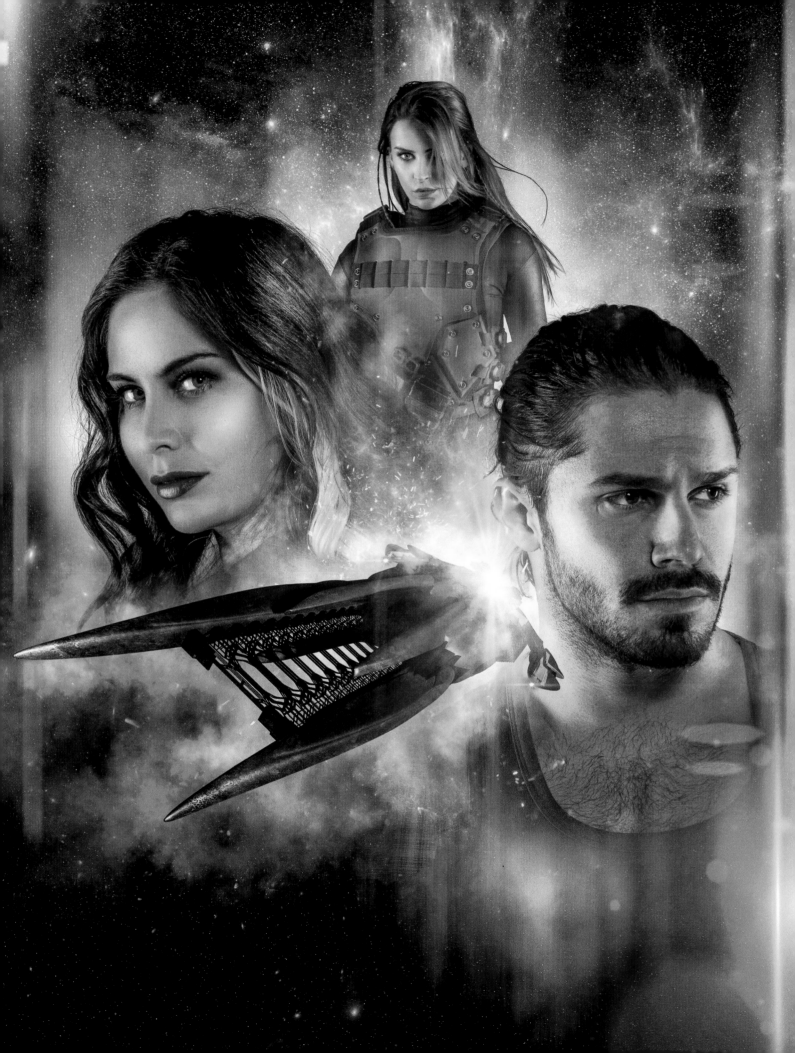

BAD COMPANY

THE BAD COMPANY

For Bad Company, Craig wanted to change the style of the covers entirely to something a little more Sci-Fi. As a fan of Star Trek, he liked the idea of the floating heads in space look, which is often used on Star Trek posters.
I also started to use more 3D now, with Terry's ship, the War Axe, being a 3D model.

These covers made for a fun and different challenge for me.

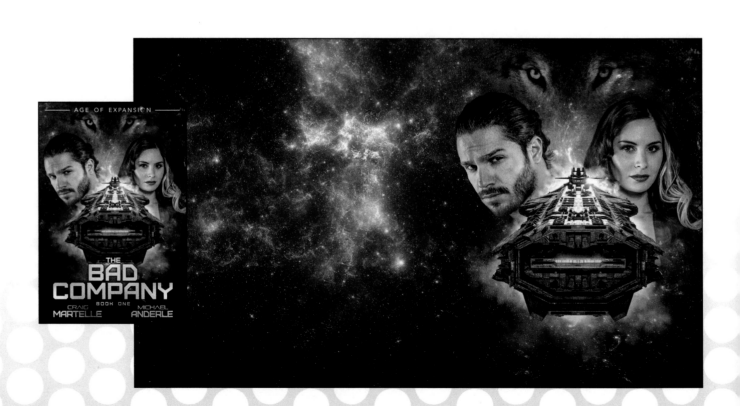

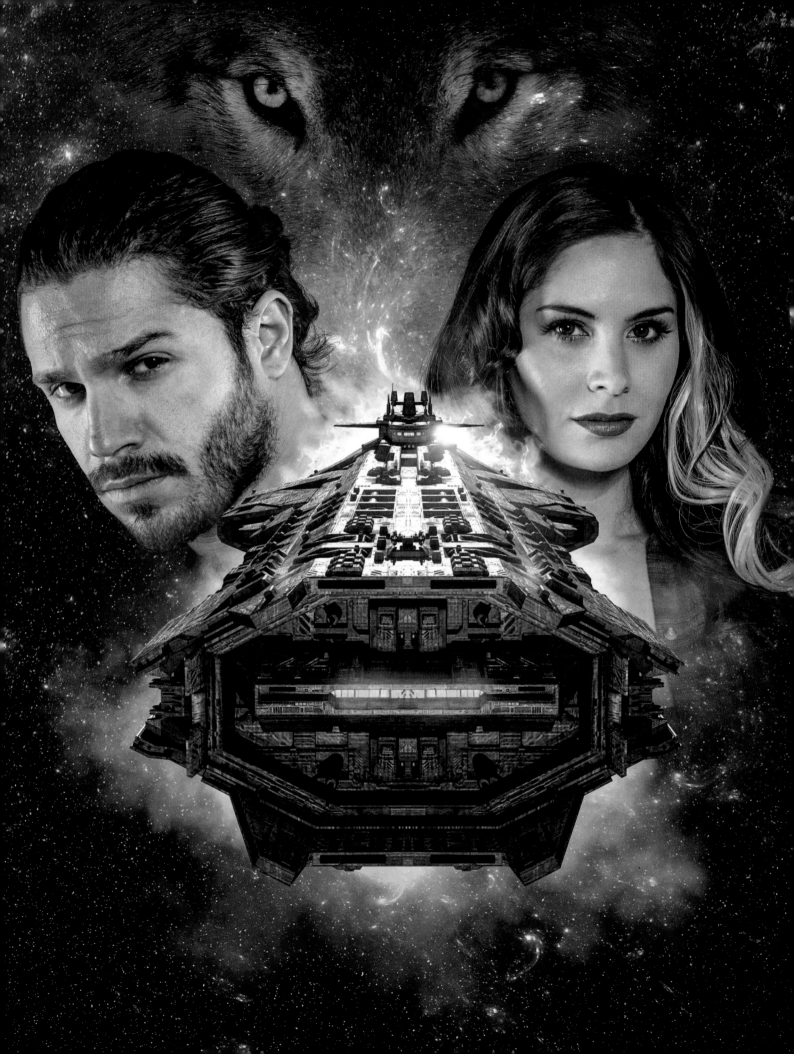

BAD COMPANY

BLOCKADE

This was one of those covers that just took ages to get right. I think we went through maybe 10 different versions before we landed on this being the final design.

The main issue was getting the ships positioned correctly to insinuate there was some kind of blockade going on.

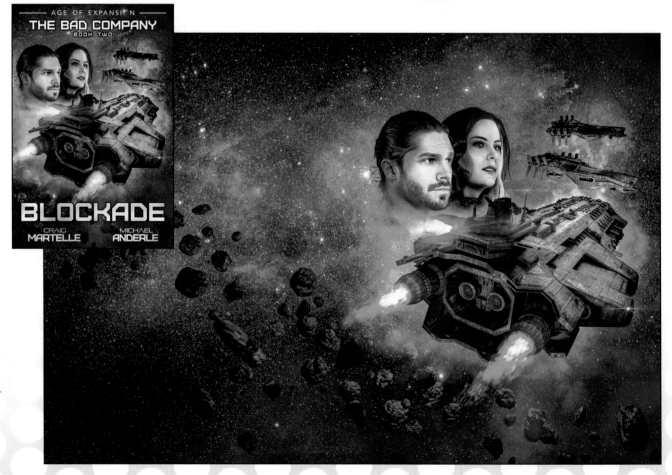

AGE OF EXPANSION

THE BAD COMPANY

BOOK TWO

BLOCKADE

CRAIG MARTELLE MICHAEL ANDERLE

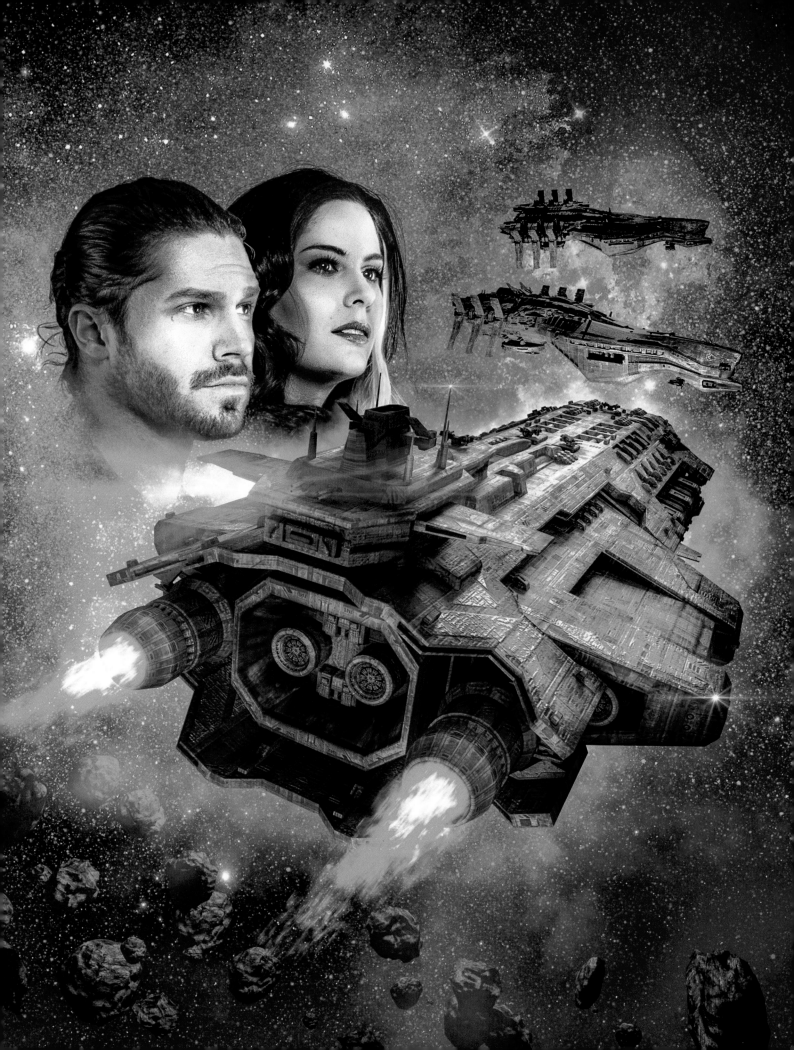

BAD COMPANY
PRICE OF FREEDOM

This cover led to another interesting challenge for me.

Craig wanted the head of one of the aliens in this book on the cover. An illustration had been created and was handed over to me for the cover (next to this text). But, as it would be right next to photos of two real people, I was worried that it might look odd next to Terry and Char.

I've worked as an illustrator for years, so I called on those skills to enhance the alien head and make it a little more realistic and detailed.

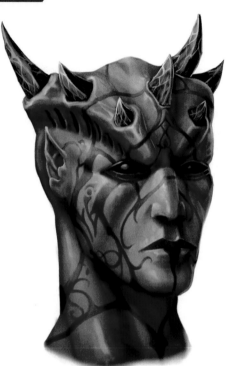

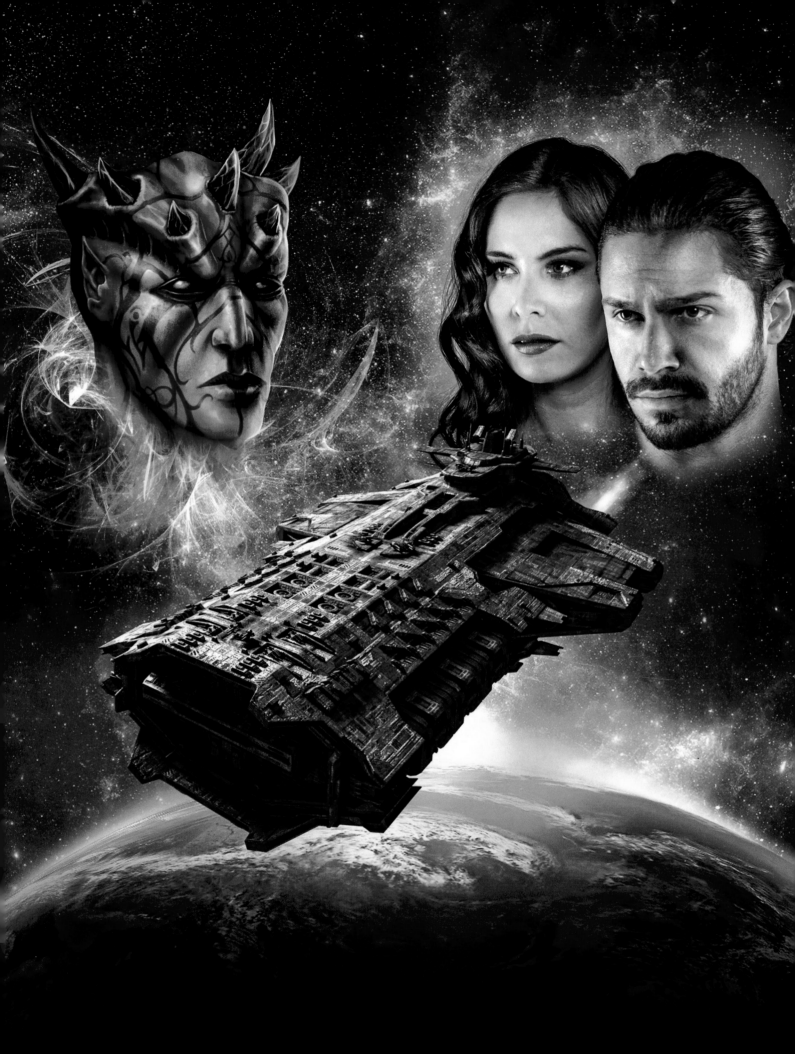

There's only so many ways you can pose a ship, but, I hope I managed to keep the images fresh and engaging.

Craig needed a digital, hacker feel to this cover, which I created with the red graphics at the top.

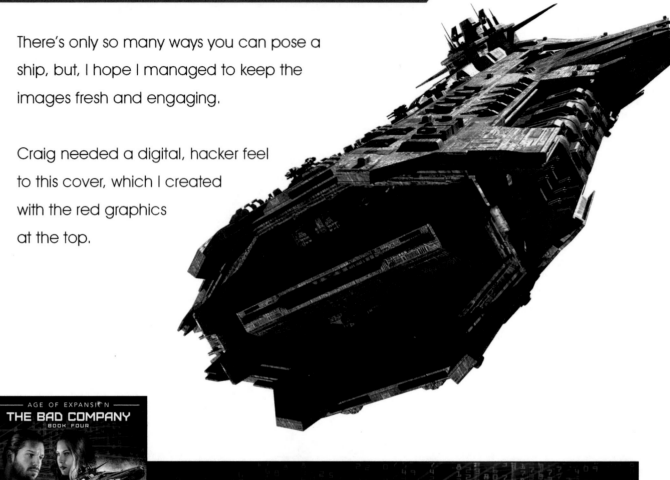

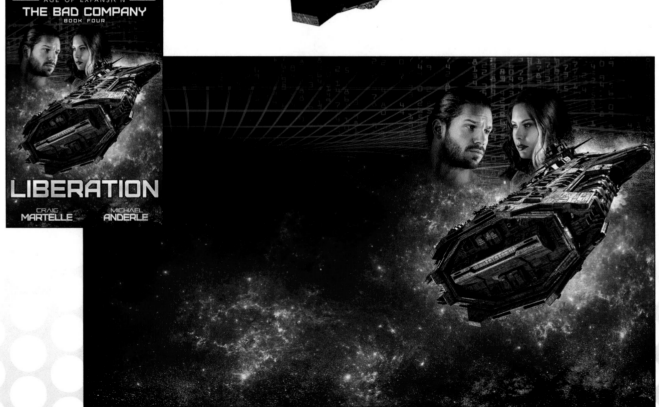

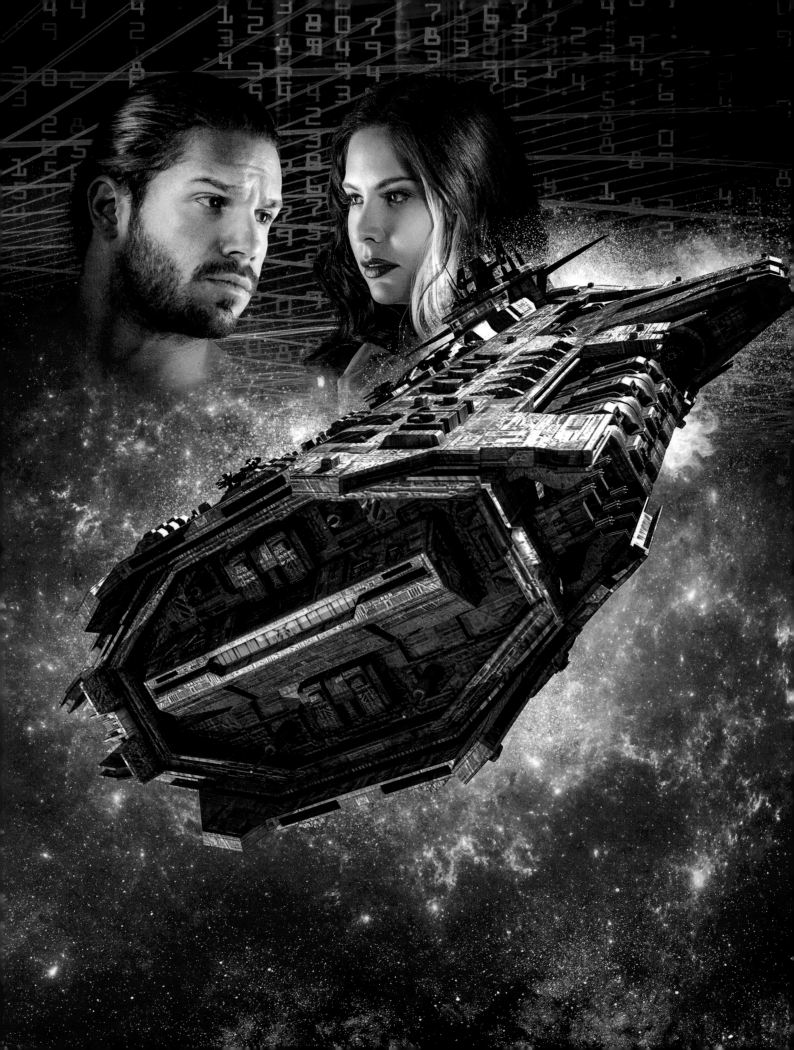

BAD COMPANY
CURRENTLY UNPUBLISHED

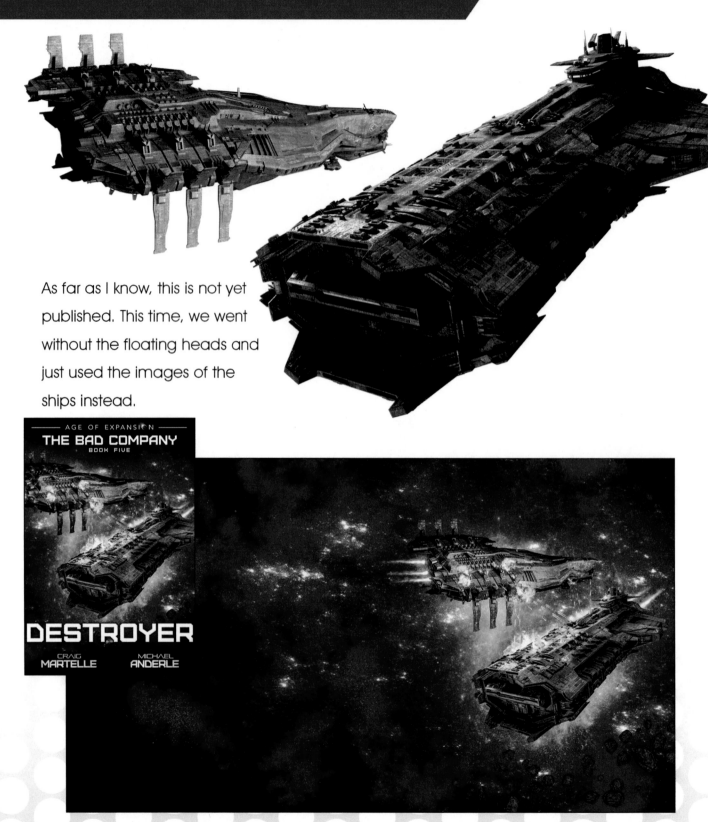

As far as I know, this is not yet published. This time, we went without the floating heads and just used the images of the ships instead.

AGE OF EXPANSION
THE BAD COMPANY
BOOK FIVE

DESTROYER

CRAIG MARTELLE MICHAEL ANDERLE

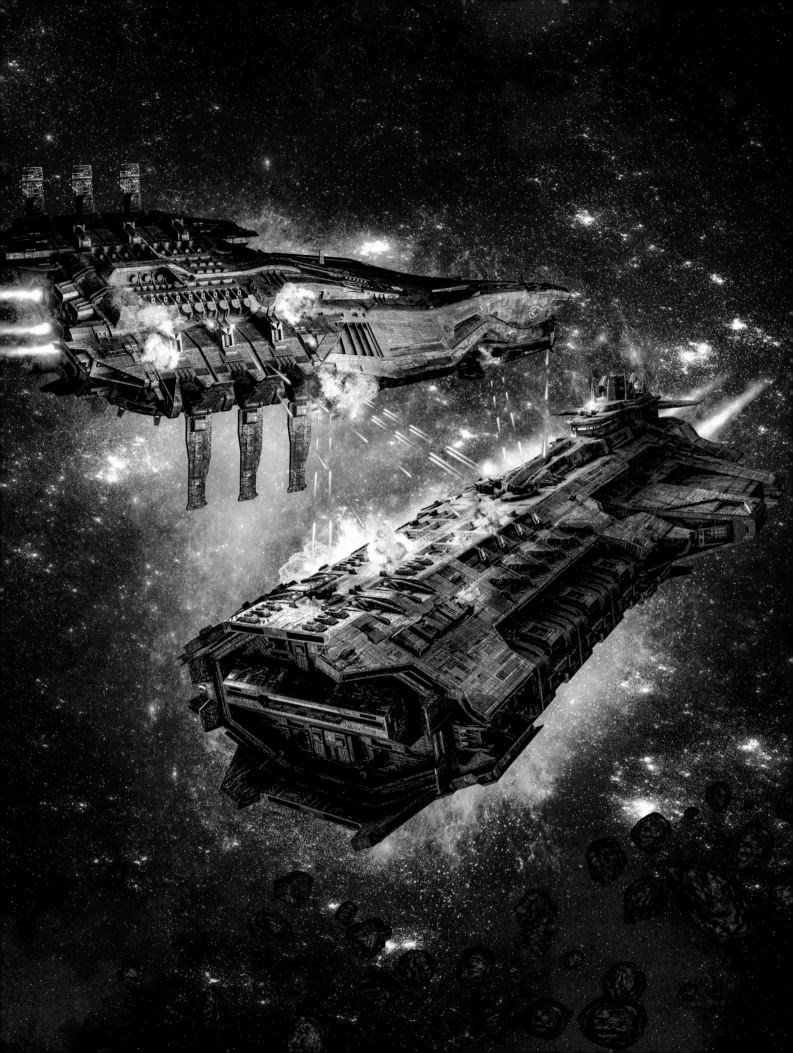

GHOST SQUADRON
FORMATION

Ghost Squadron was another series set in the age of expansion off-shoot from the Kurtherian Gambit series. It also gave me the opportunity to work with Rosie Robinson, a fitness and fashion model I was aware of.

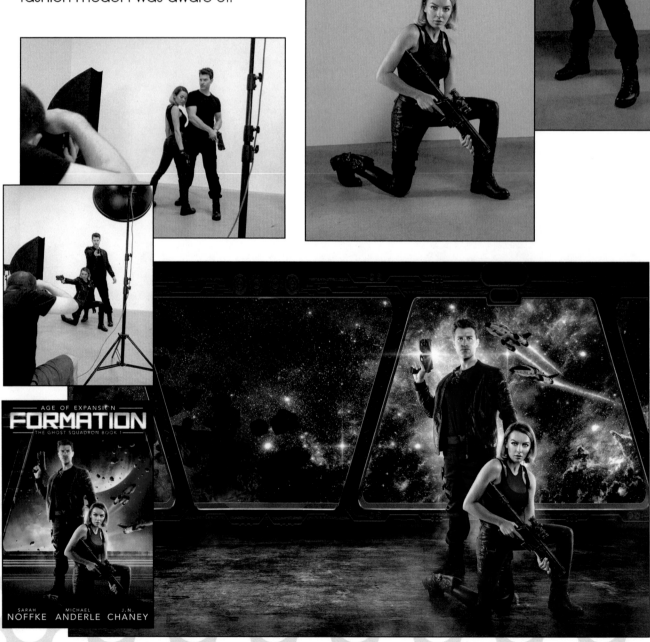

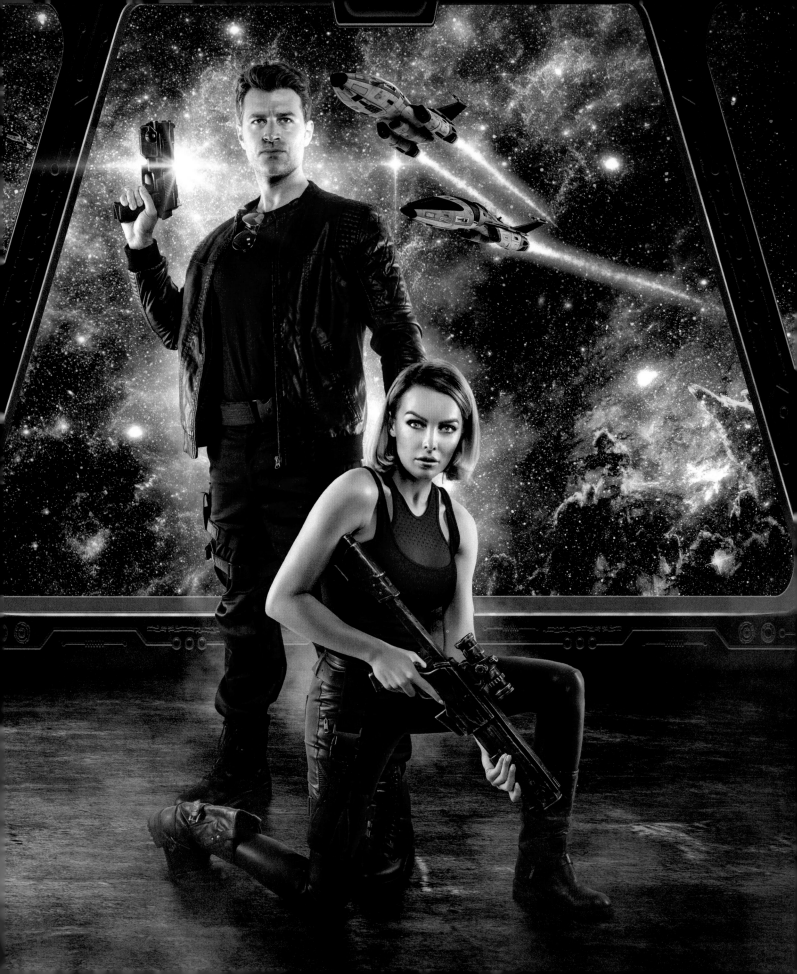

Both models were professional and friendly, but we didn't count on the height difference between them.

In the books, I believe the characters are MUCH closer in height to each other, so this led to some massaging of their size to reduce the difference between them.

Using these sitting images was one way of achieving this.

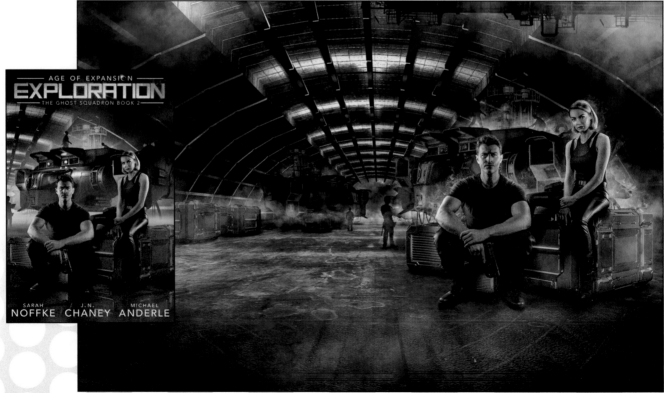

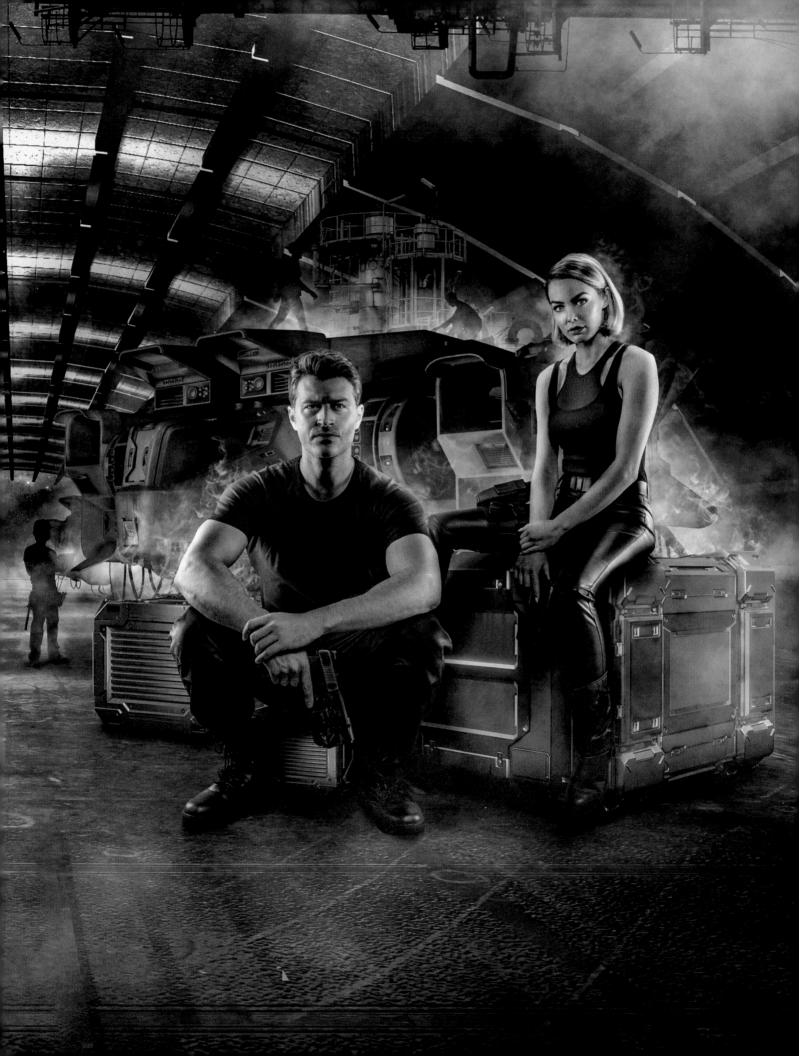

GHOST SQUADRON
EVOLUTION

Cover creation is a complex business, and there are times when changes need to be made to the cover after I've finished it, for whatever reason.

You'll notice that the final printed covers for this series differ from the image to the right, which is the one I sent in.

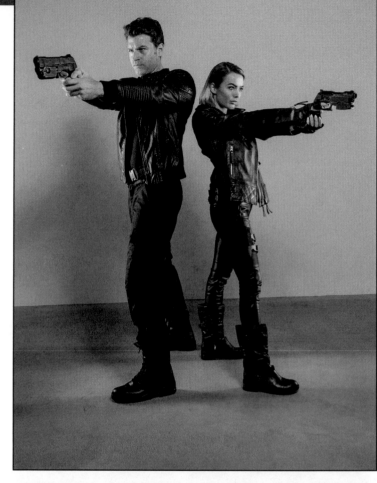

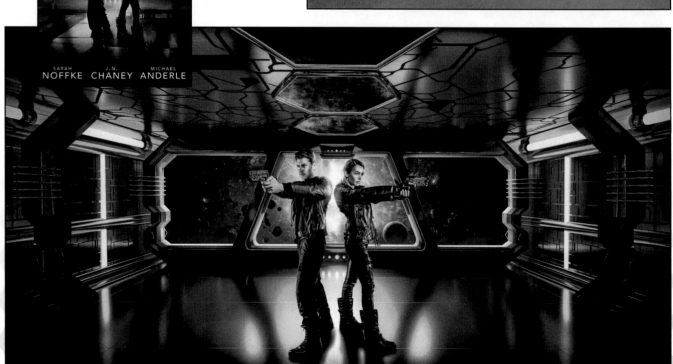

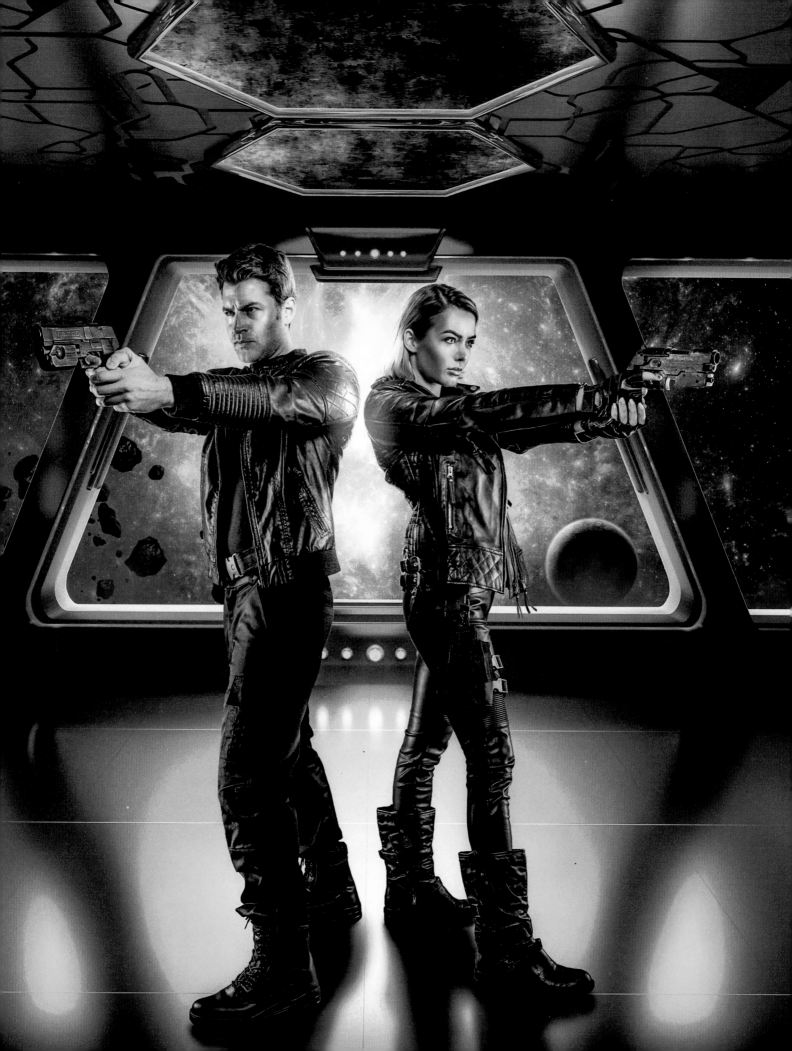

I enjoyed creating the dramatic explosion and lighting in this image.

After all, nothing says cool like not looking at an explosion that's going off behind you!

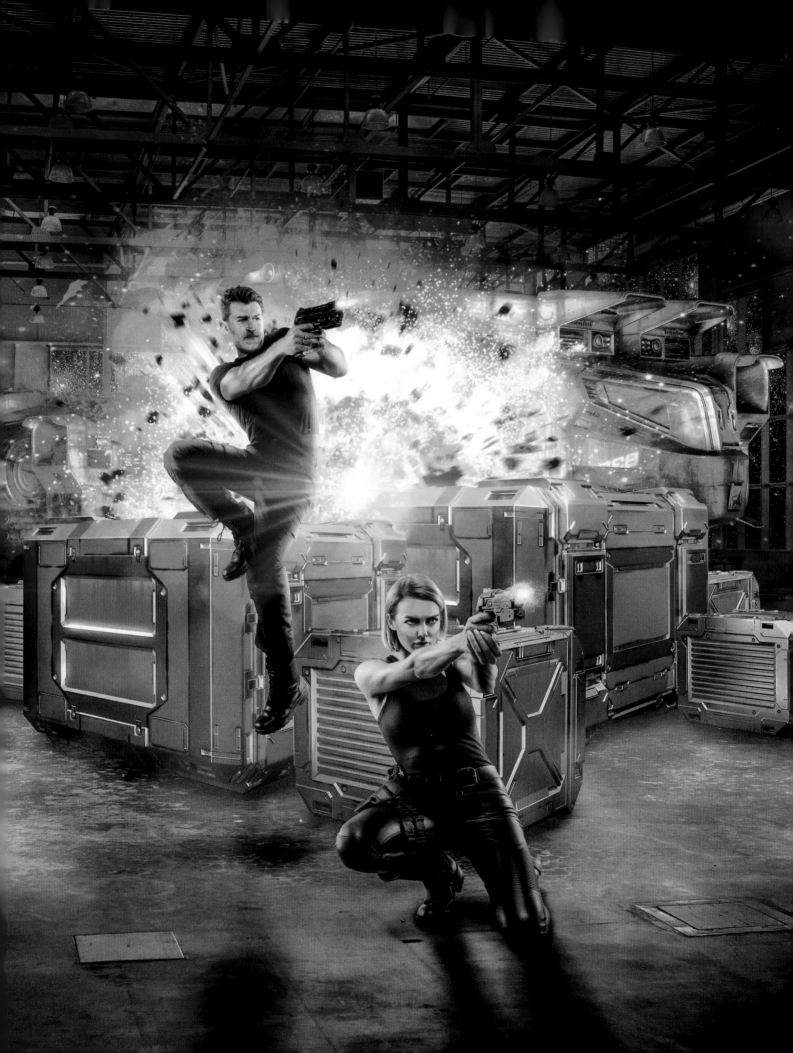

GHOST SQUADRON
IMPERSONATION

Sometimes, it's not just the heads that need swapping, sometimes, it's an entire body.

Luckily, Photoshop is an awesome tool.

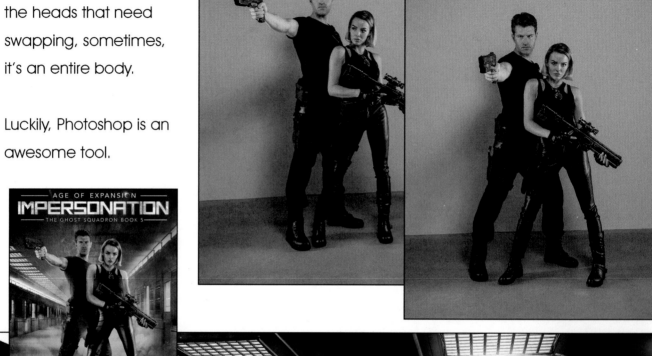

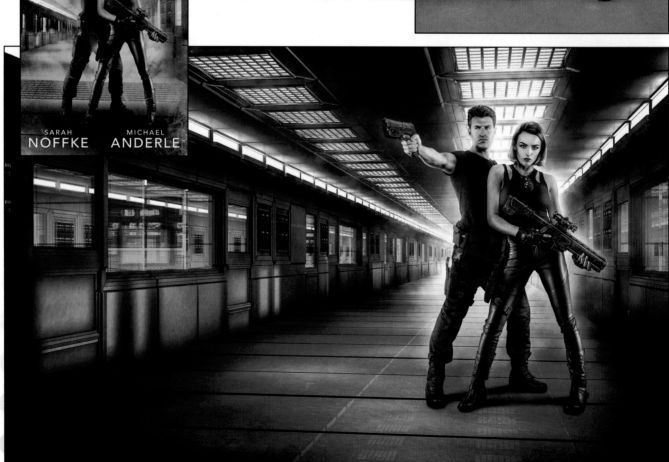

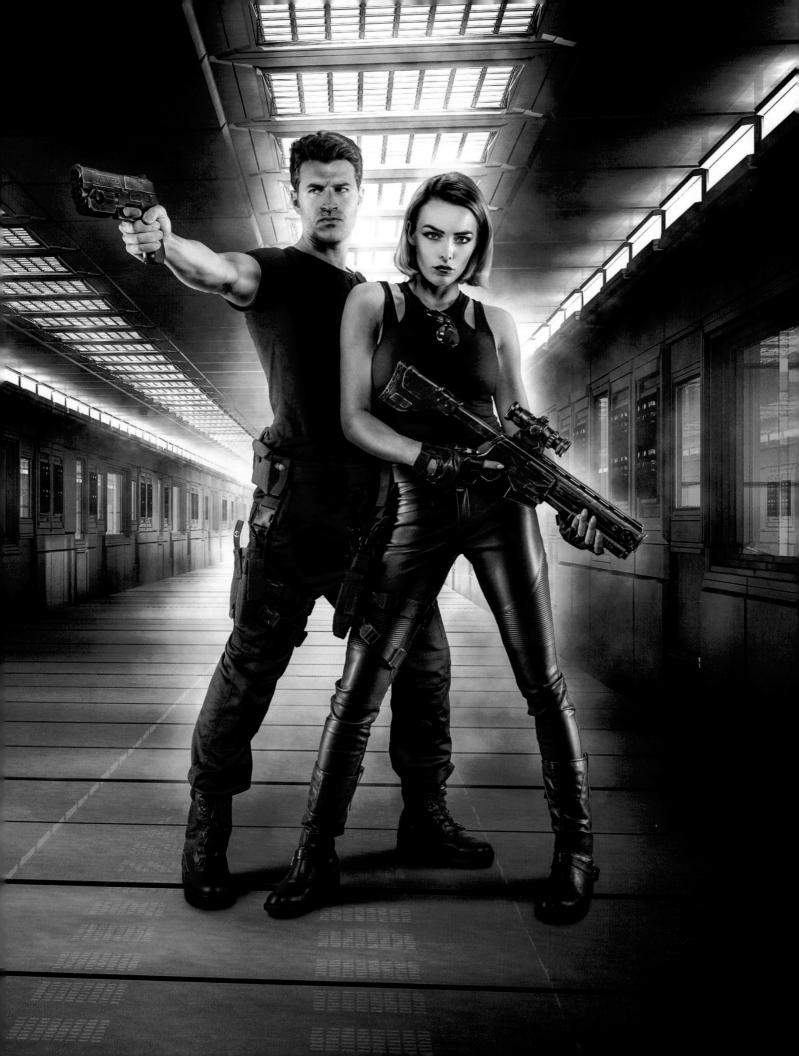

GHOST SQUADRON

RECOLLECTION

The last cover I created for this series.

I was asked to ass in some classic cars into the background of this spaceship hanger to reference a plot element, which made for an interesting hunt through stock images.

We also see another clever shot to hide the difference in height between the two models.

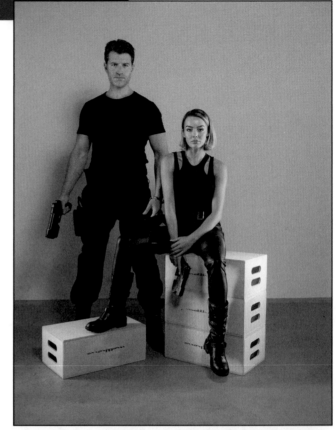

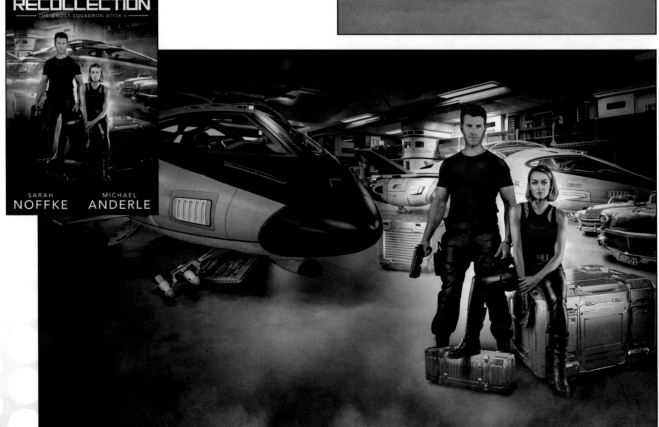

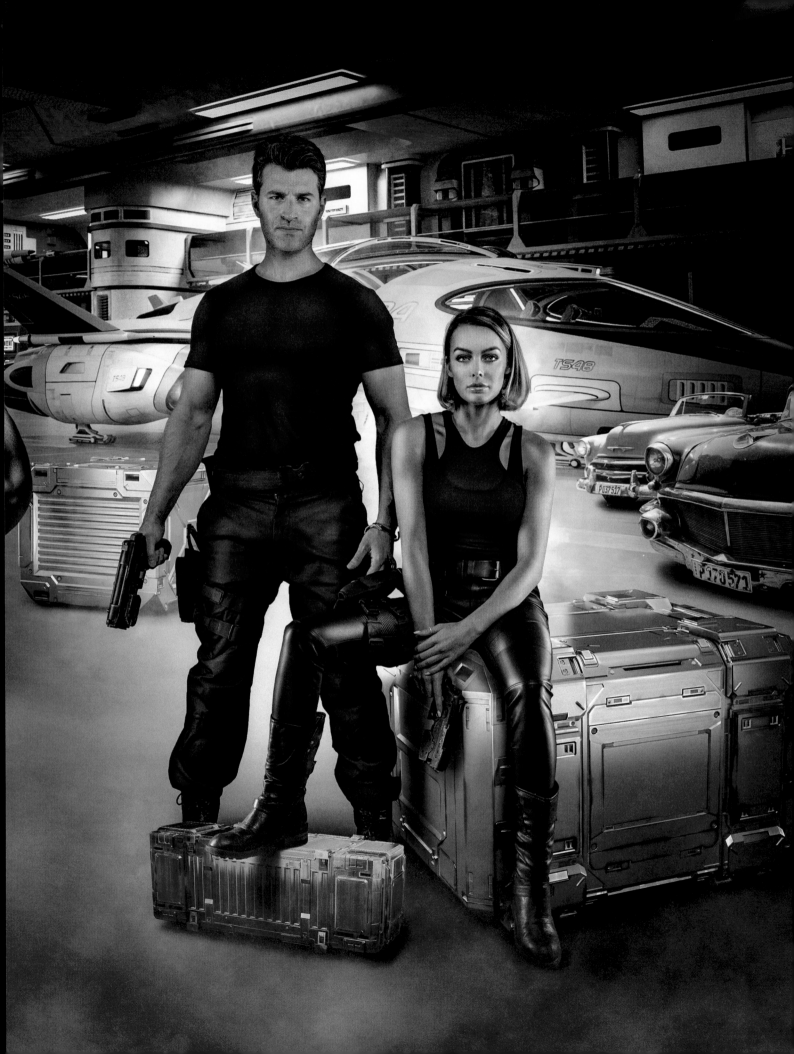

UPRISE SAGA
COVERT TALENTS

The covers for this series were interesting to create, and I ended up creating two versions of the first three of them.

Below, you can see the original version, with the full body shot of the model. However, it later became clear that for whatever reason, this wasn't resonating with the readers. So, after finishing the third cover, a new direction was chosen.

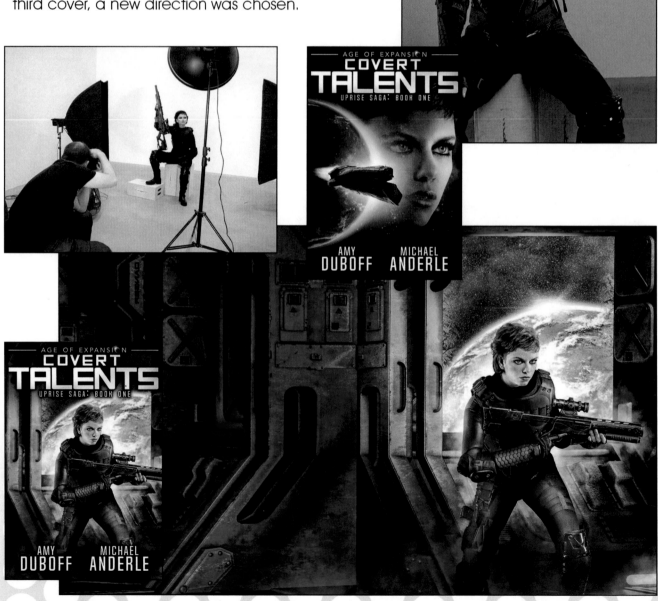

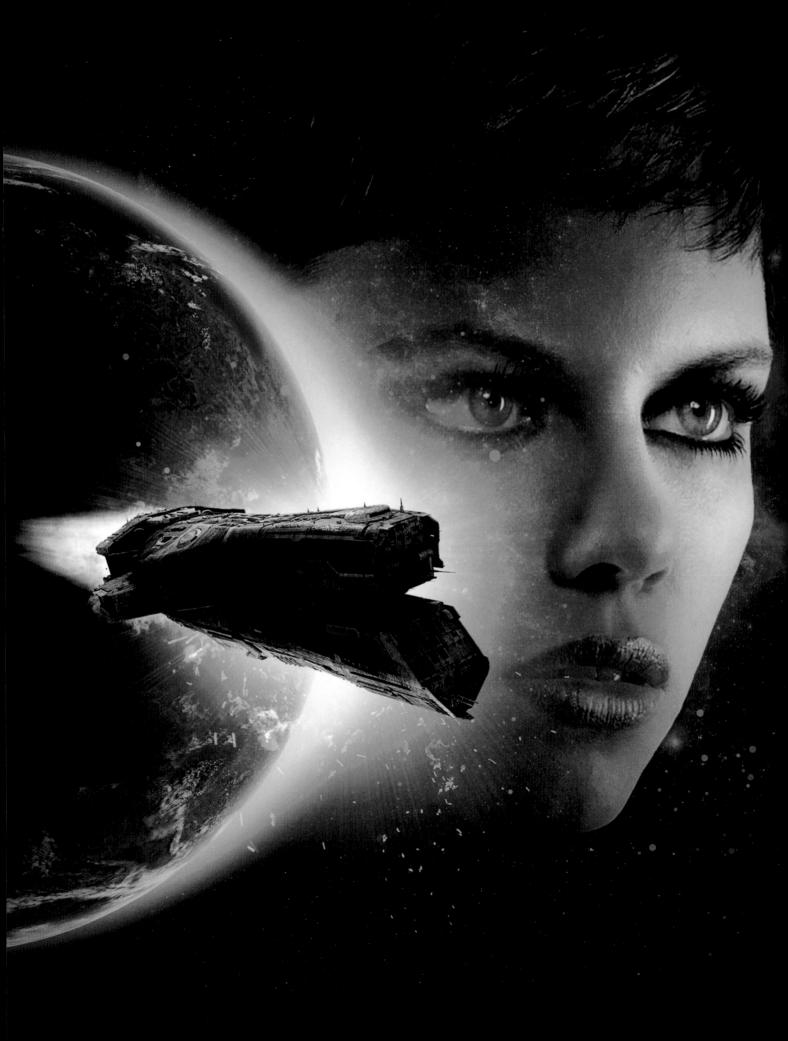

UPRISE SAGA
ENDLESS ADVANCE

We hunted around for a while, trying to find the right look for this series and its new covers.

In the end, we took inspiration from some of Peter F. Hamilton's recent covers, and went with a floating head look, using a ship and planet, with strong colours.

The new covers were a much better fit, and I was rather pleased with them really.

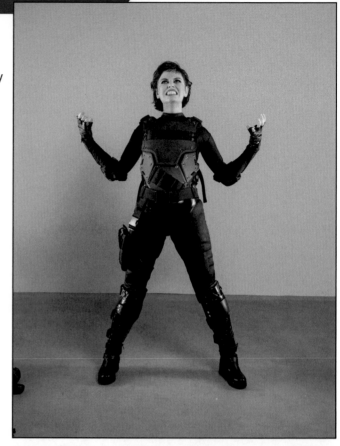

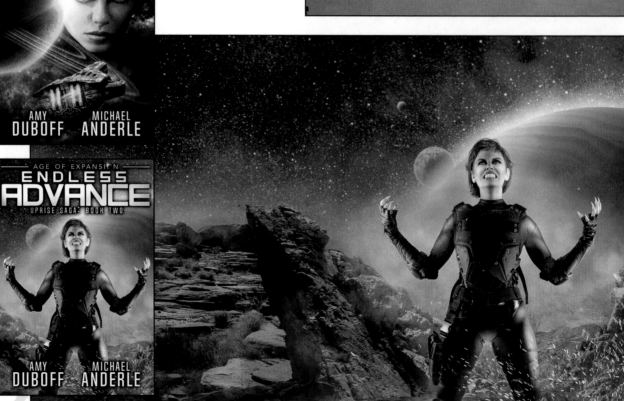

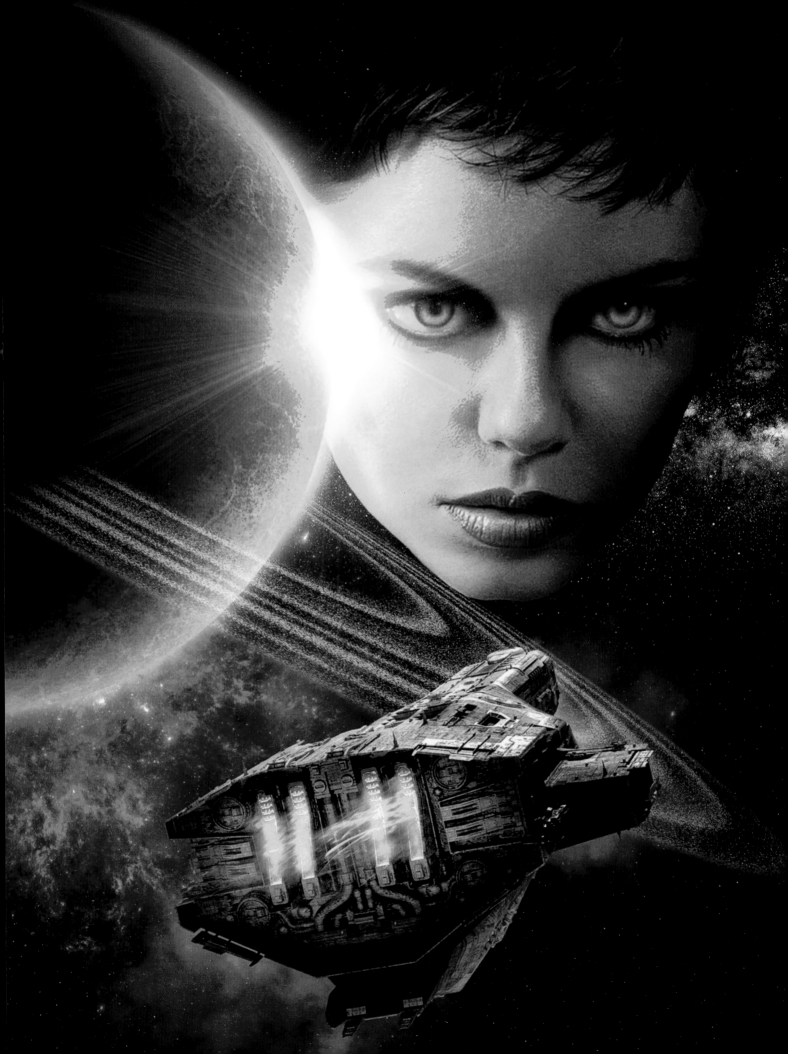

UPRISE SAGA
VEILED DESIGNS

I enjoyed playing with this more stylised look for these covers, and it allowed me to use some more retro elements, such as the blue fractal on the right-hand side of this third cover.

I love the colours on this one too.

The model, Estrany, was fun to work with, but this was one of her last ever shoots, as she retired from modelling shortly afterwards.

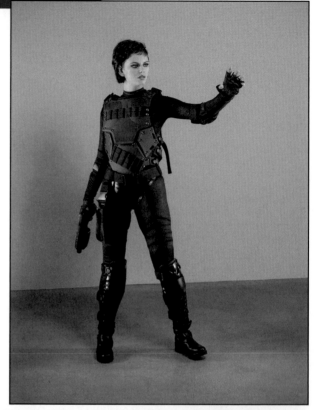

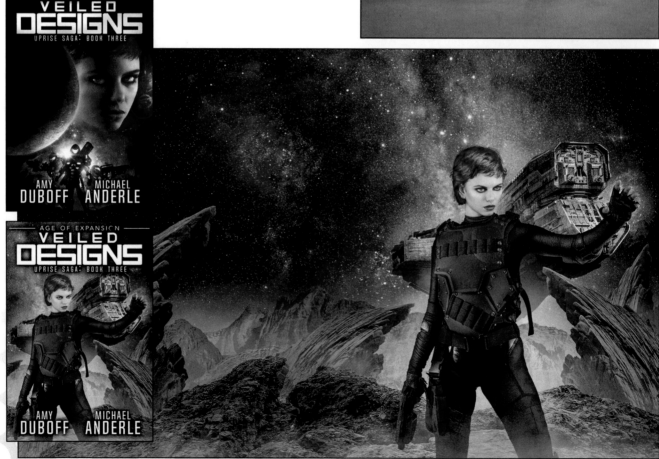

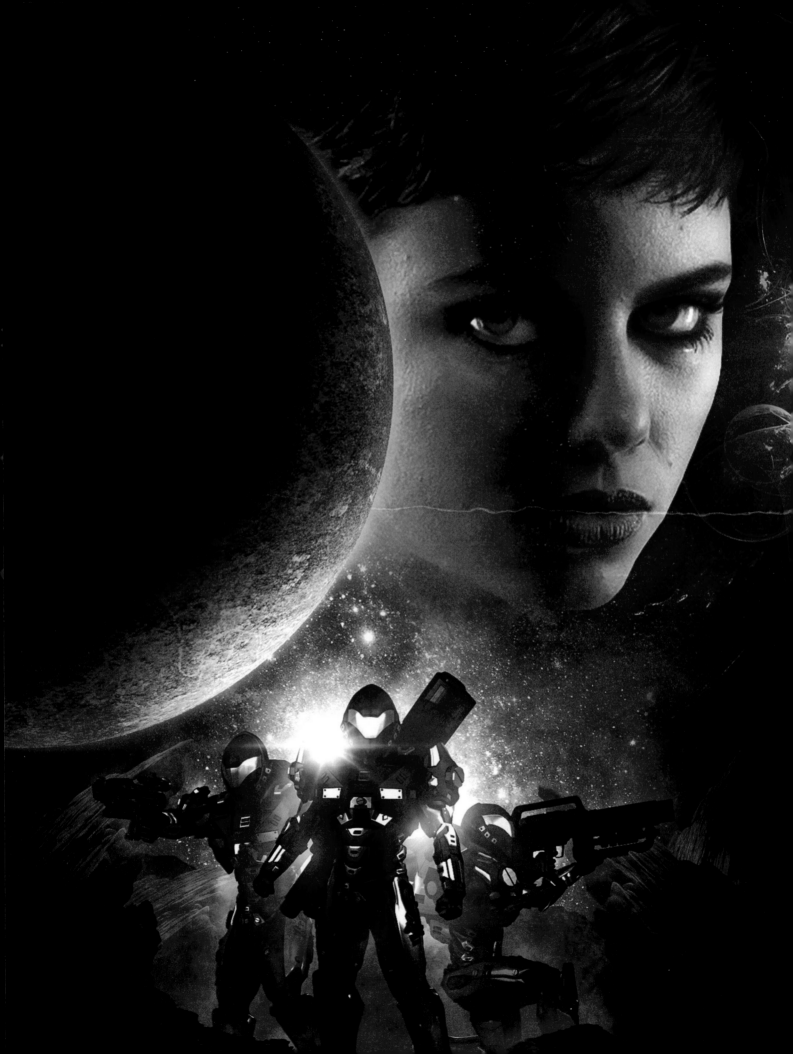

UPRISE SAGA

DARK RIVALS

For this last one, Amy Duboff, the Author, needed her very own "Death Star" for the cover, and it was up to me to create one.

You can see the result on the right, and its final look on the cover far right.

I included the starship renders of the 3D model below as well.

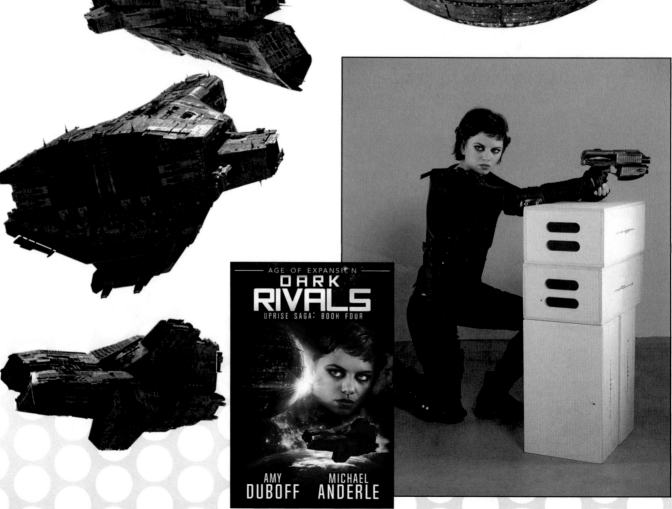

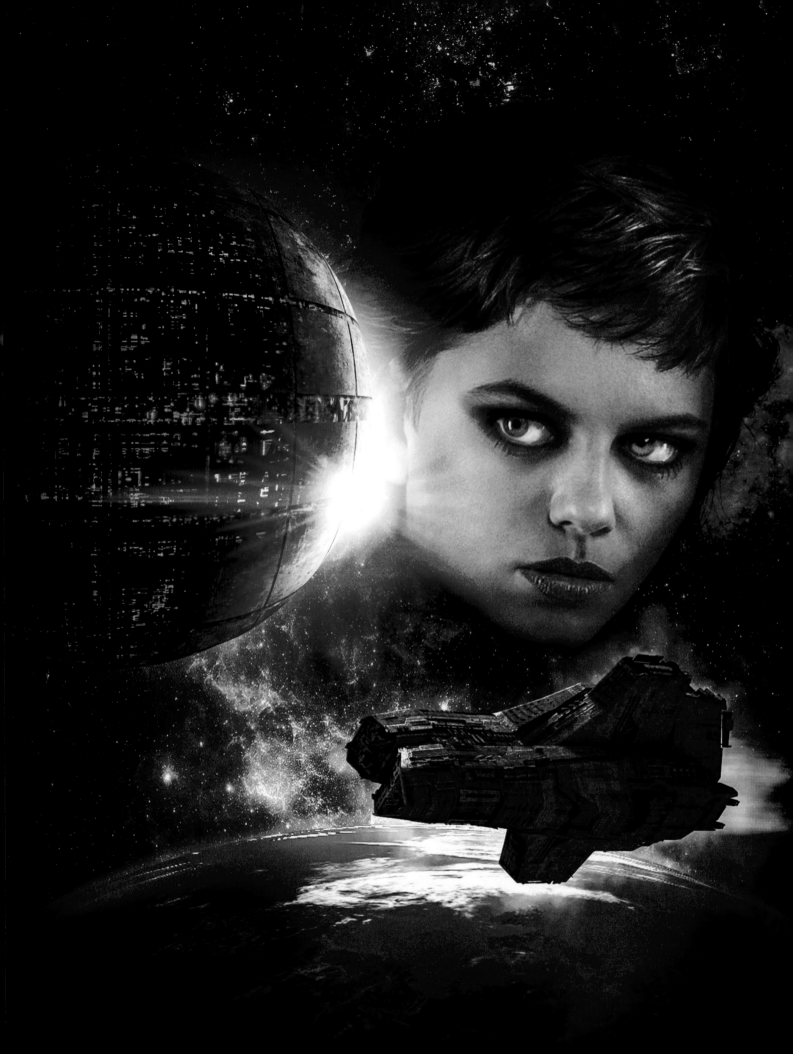

SHADOW VANGUARD
GRAVITY STORM

The Shadow Vanguard series was a more recent addition to my cover work, working with Tom Dublin. The concept of the pair wearing boiler suits was certainly an interesting one.

The one the girl wore was way to big for her, so we ended up cutting it up to tie it about her waist. It took some work to make it look good, but my friend Make Up Artist is great at this kind of thing.

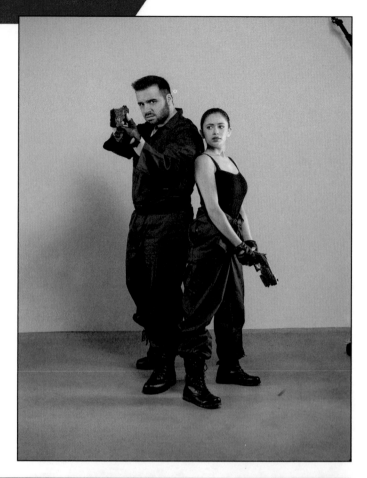

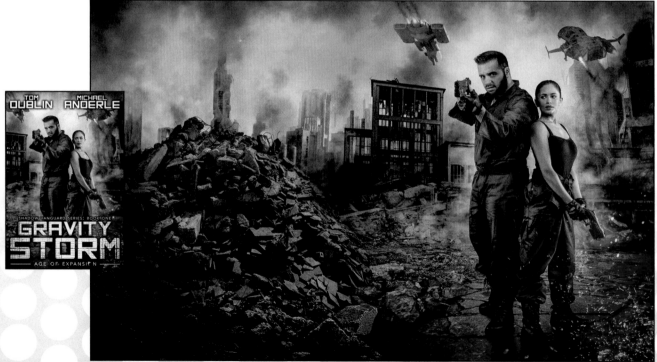

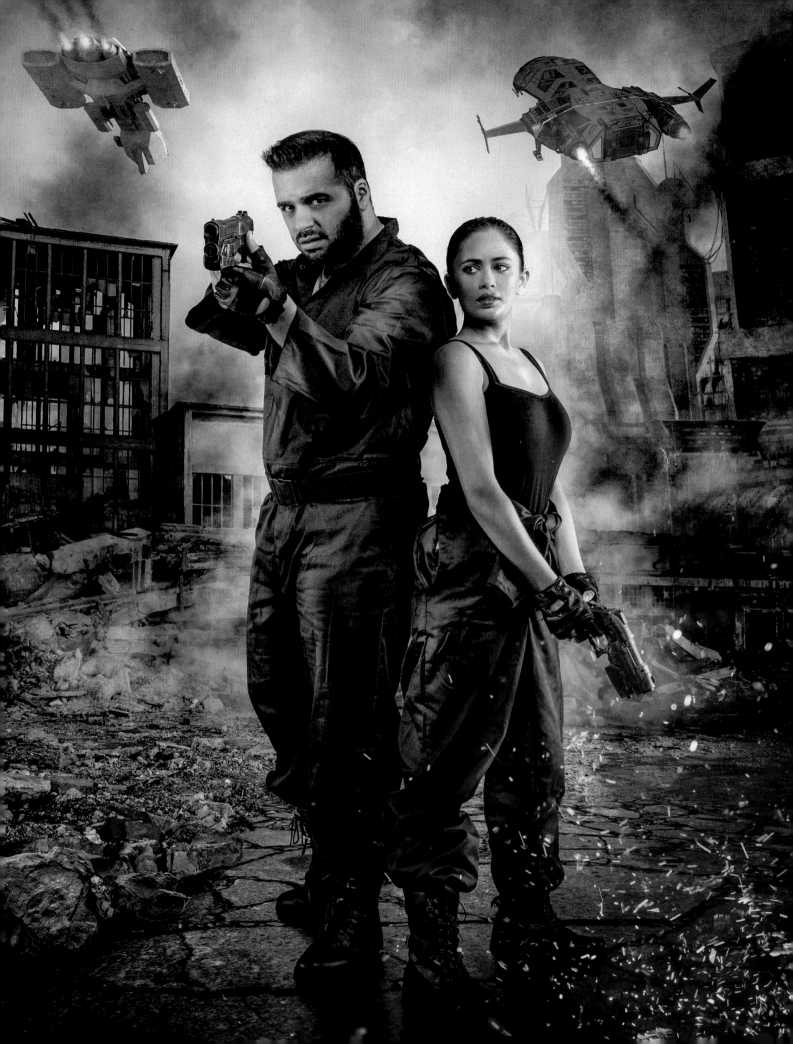

SHADOW VANGUARD
LUNA CRISIS

The background for this one is a conplretly 3D generated scene, further enhanced in Photoshop once it was rendered out.

Tom wanted a seedy looking futuristic, bladerunner like city for our heroe's to be sneaking through.

Again, two seperate photos were used for the models.

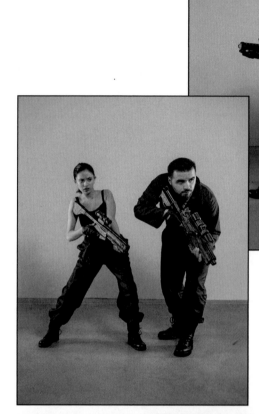

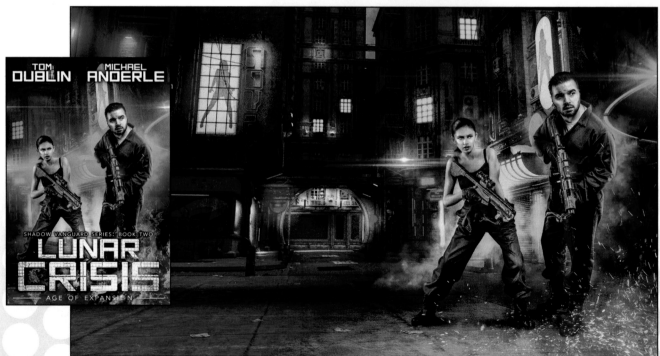

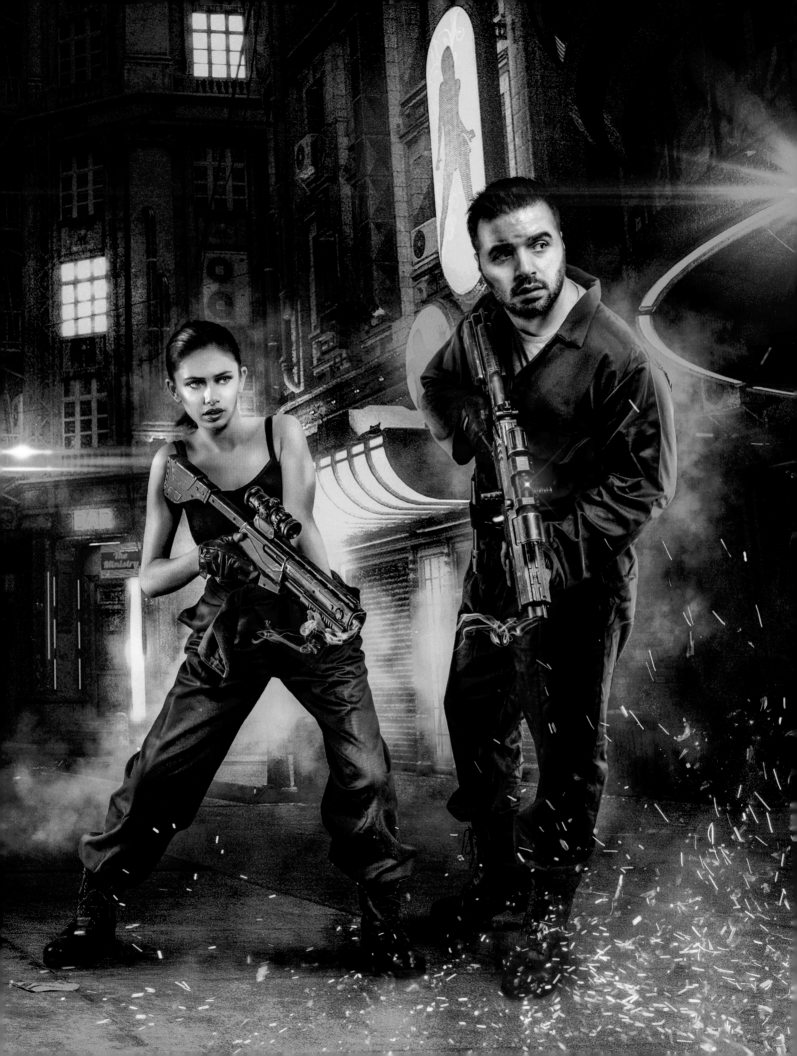

THE KURTHERIAN ENDGAME

PAYBACK IS A BITCH

The Kurtherian Gambit reached it's finale with book 21, "Life goes One", but Bethany Anne's story is far from over, so new covers were needed.

Michael has been exploring the possibilities of 3D for a while, with some of his newer series having totally 3D covers.
For Endgame, it was decided to use a 3D body, but keep Helen Diaz's head.

I was provided with a 3D render of Bethany Anne's body, and went to work creating the final look with the background and head.

It was a fun project to work on. You can see alternate colour schemes below.

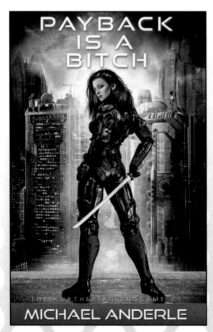

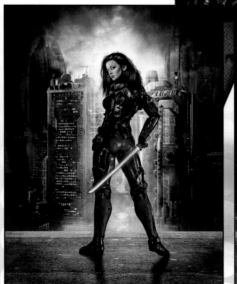

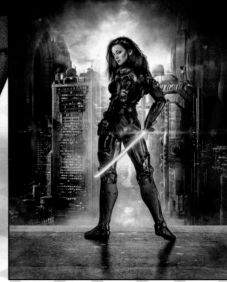

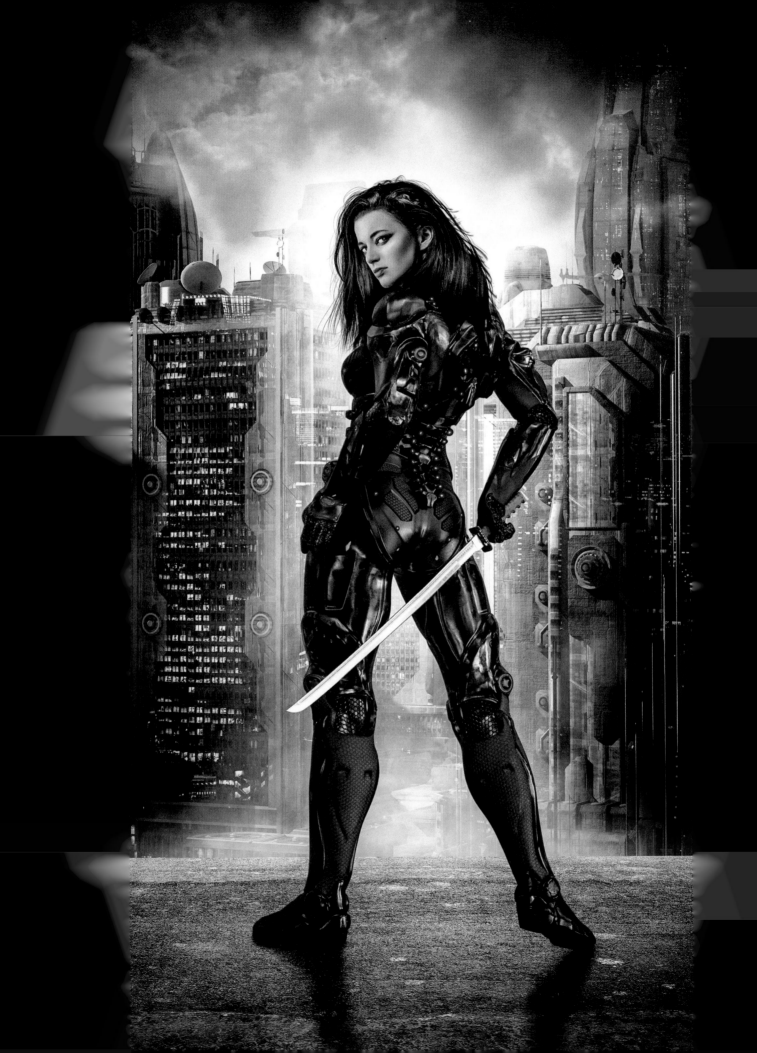

Cover 2 for Endgame used the same idea of a 3D body and Photoshop for the rest.

It's always fun hunting through the photos to find the right head for Bethany Anne.

As you can see, we've shot Helen in several costumes for BA, some of which have not seen publication yet.

Her sword arm was photoshopped in from another, unused render.

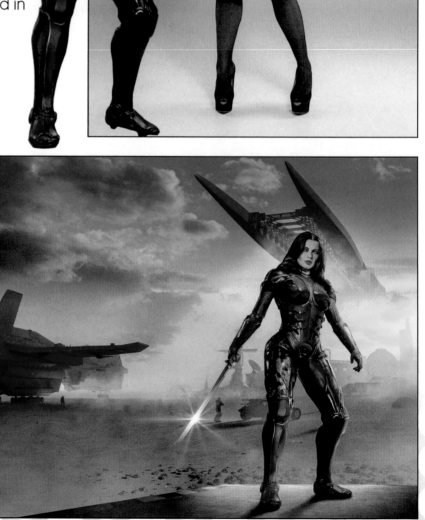

COMPELLING EVIDENCE

THE KURTHERIAN ENDGAME 02

MICHAEL ANDERLE

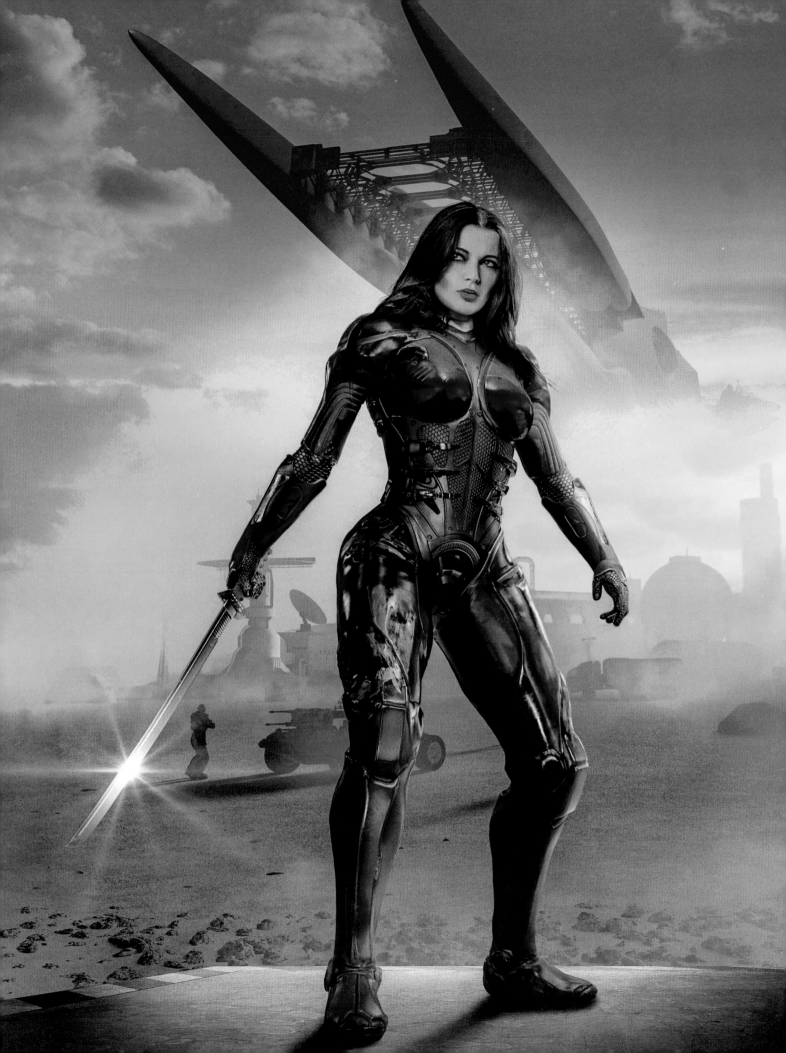

This cover was created for the first "Fans Write" book, where fans of the Kurtherian Gambit got to write stories set in this world, and have them published.

That was another one where I was given the background and had to photoshop the model into the scene.

Of course, it had to be Bethany Anne.

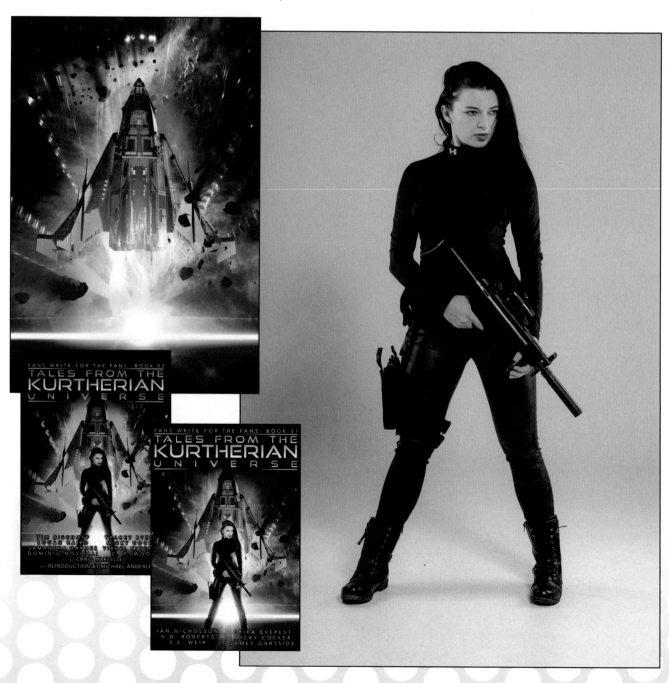

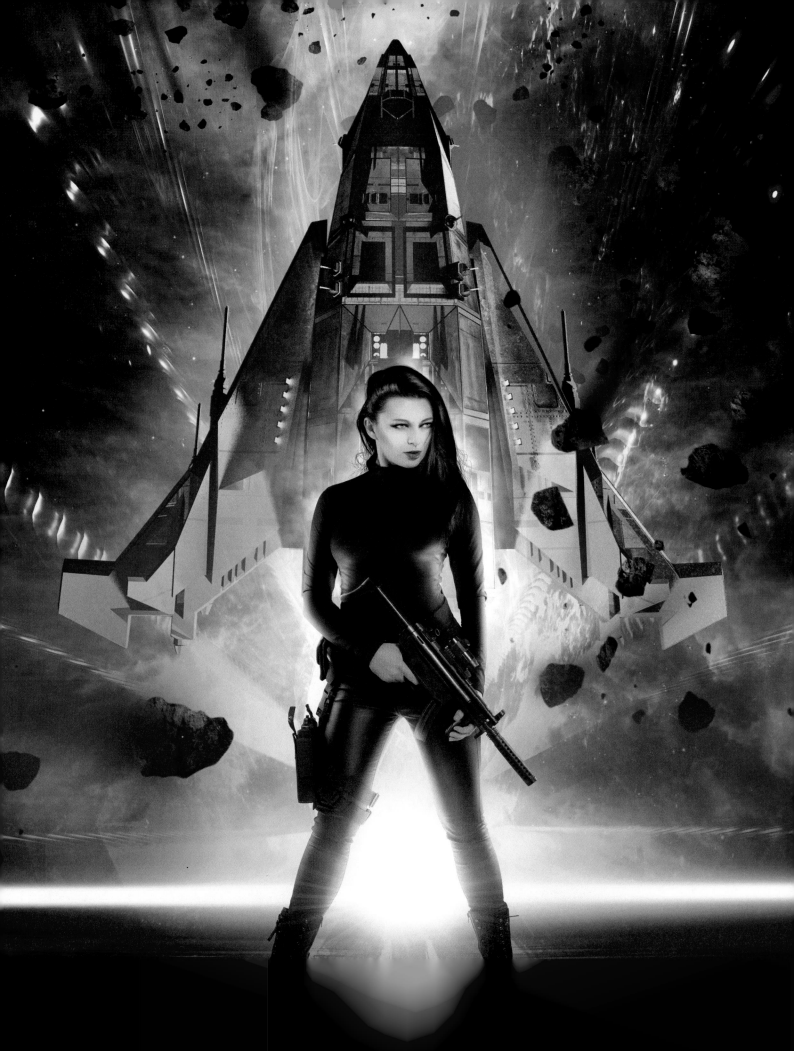

OTHER AND UNPUBLISHED
VAMP OUT & BABA YAGA

There have been a number of images created for the Kurtherian Gambit that have not seen publication for one reason or another. The image on the right is one such example, mainly because it didn't test well with the fans. It was a shame because I was really happy with it. Plus, it was fun to shoot.

In the end, it was repurposed as a Baba Yaga teaser/test image (below).

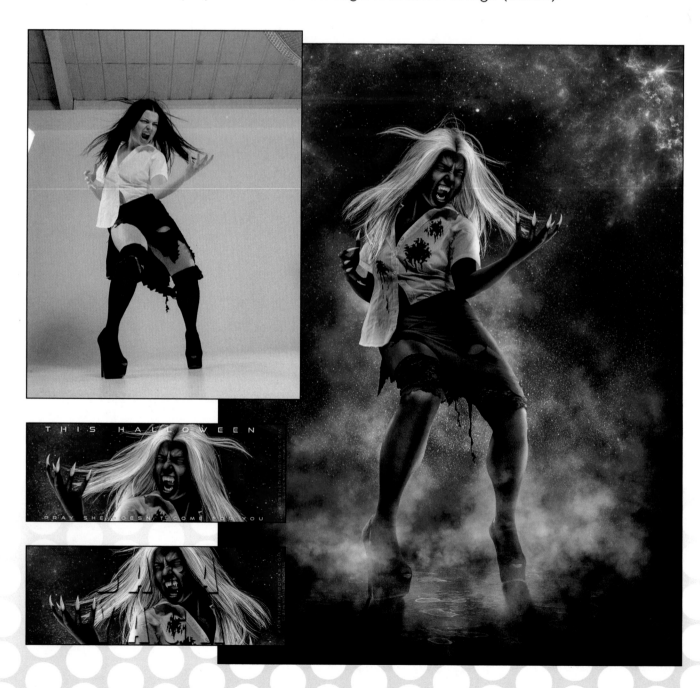

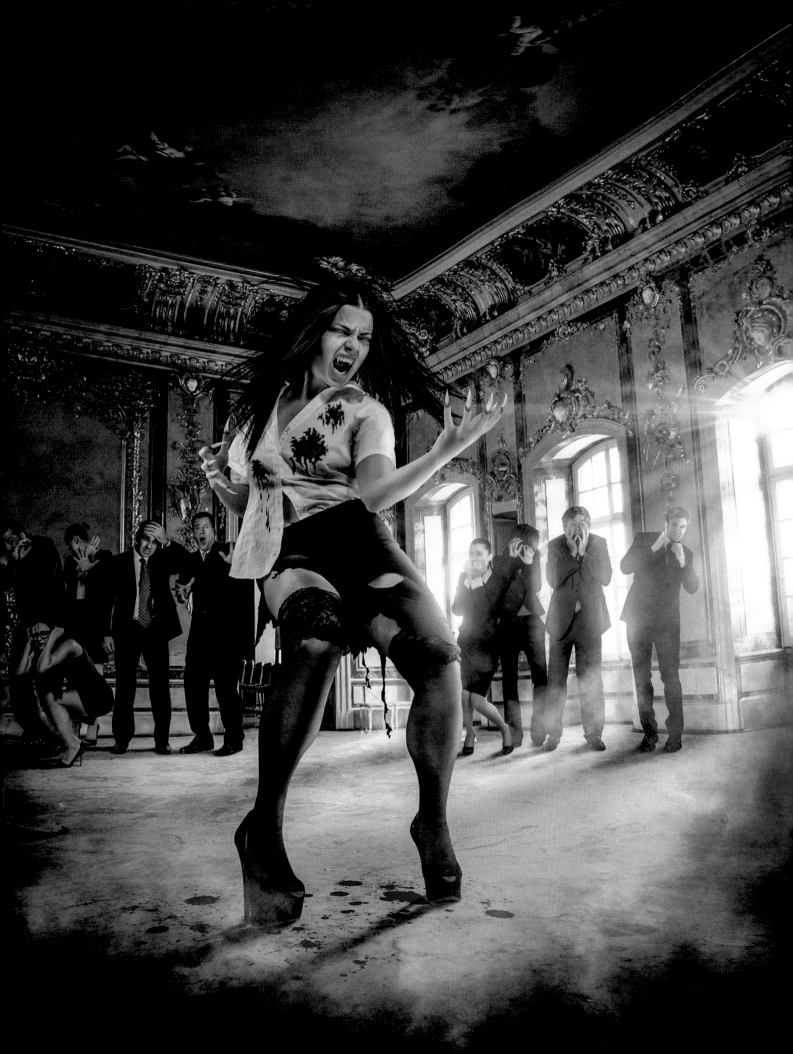

To the right, you can see the original, unpublished cover to book 6 of the Kurtherian Gambit.

That's a baby she's meant to be carrying, though, I think we used a pillow if I remember rightly.

This never saw print though, as a new direction was chosen.

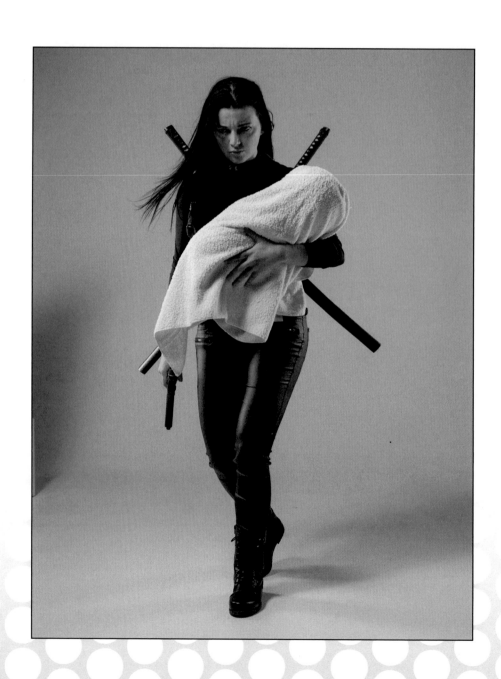

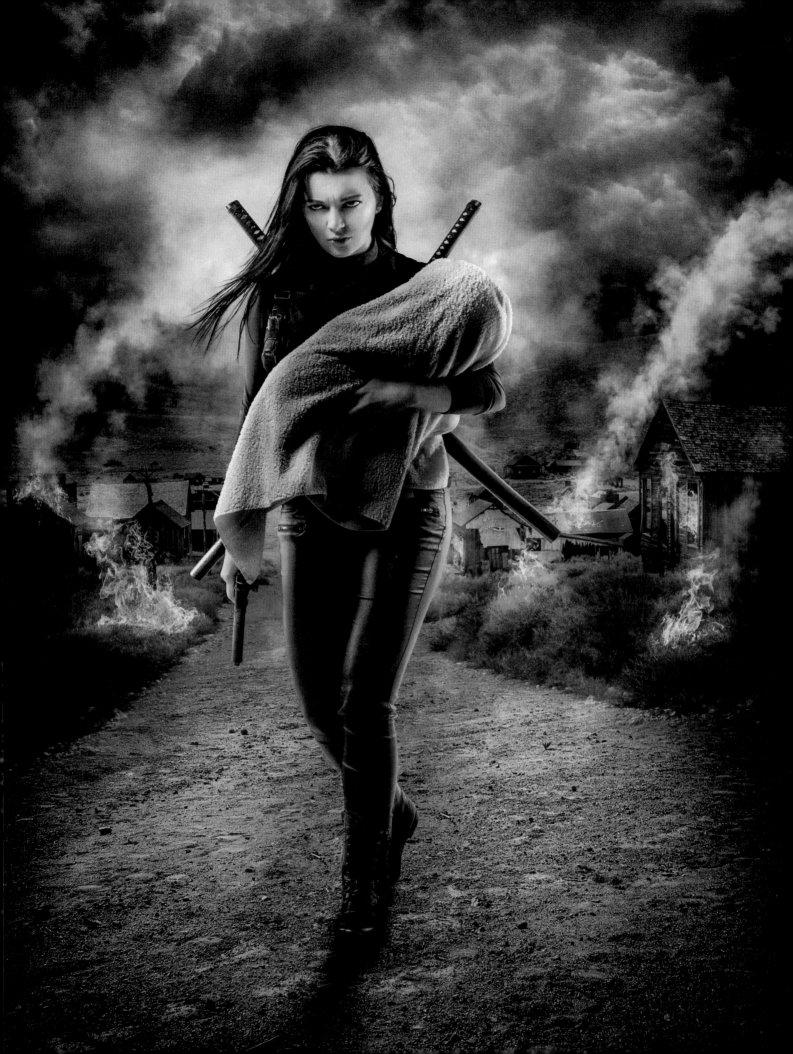

Book 7 had a similar thing happen to it, with the original cover (on the facing page) being scrapped for something slightly different.

I liked this cover, so it was a shame to see it go unused, but, at least it sees print here.

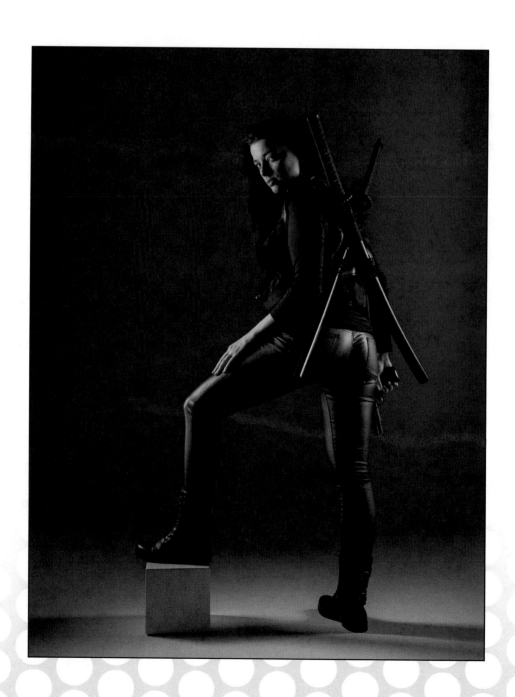

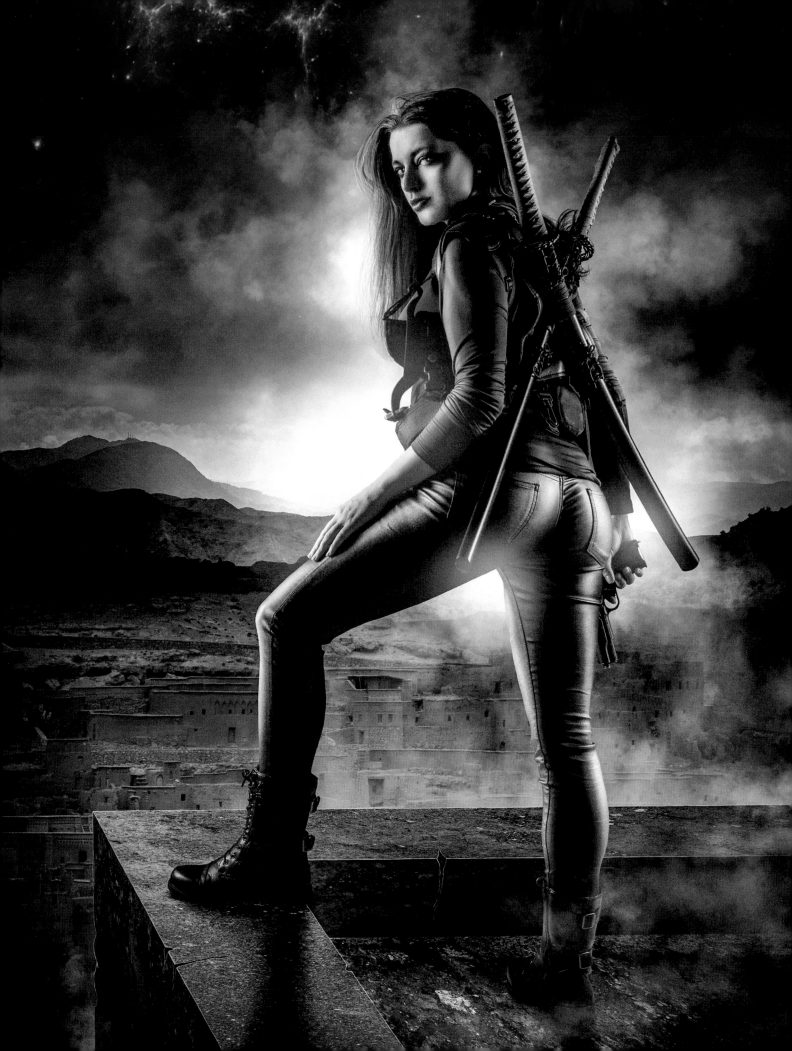

Sometimes, I'm commisioned to do a shoot, but end up not being able to do the covers.

Valeries Elites was one such project.

The shoot was great, and I got to produce a couple of concepts, which you can see on these two pages, but ultimatly, a different direction was chosen. See below.

AGE OF EXPANSION
BOOK 1 IN THE VALERIE'S ELITES SERIES
VALERIE'S ELITES
JUSTIN SLOAN · PT HYLTON · MICHAEL ANDERLE

AGE OF EXPANSION
VALERIE'S ELITES BOOK THREE
PRIME ENFORCER
JUSTIN SLOAN · PT HYLTON · MICHAEL ANDERLE

AGE OF EXPANSION
VALERIE'S ELITES BOOK TWO
DEATH DEFIED
JUSTIN SLOAN · PT HYLTON · MICHAEL ANDERLE

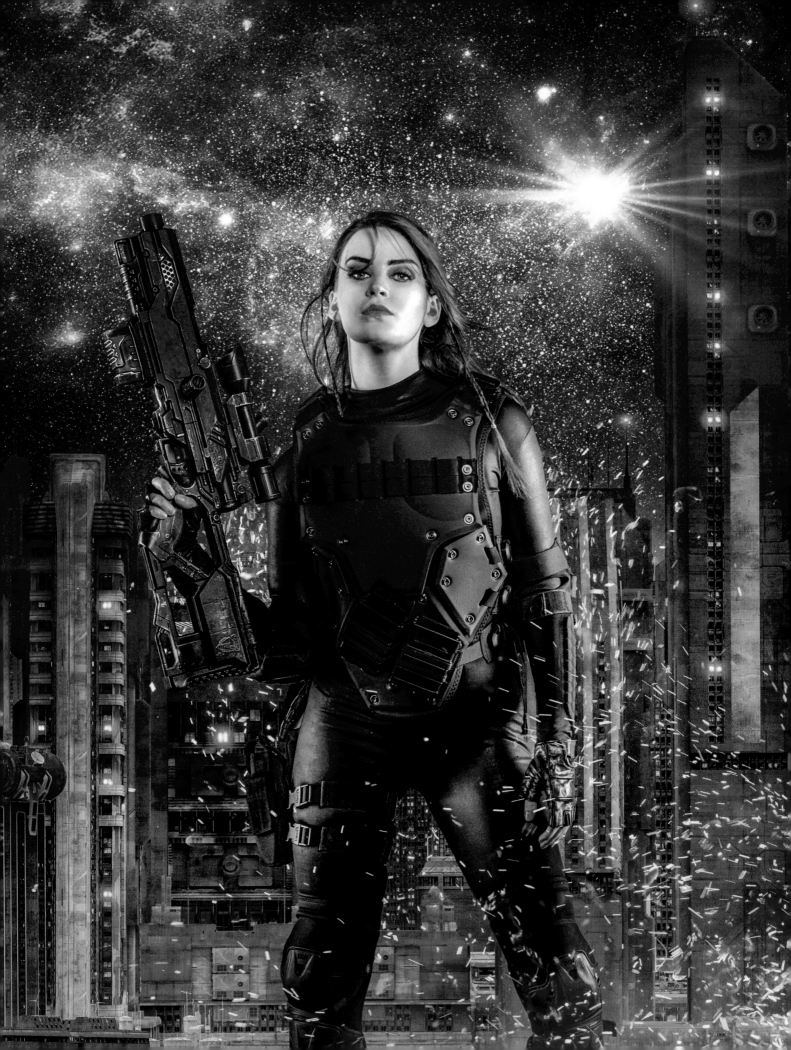

Not everything created is designed for covers though, and the images on these two pages, and overleaf, were created to be used in the advertising of the Kurtherian Gambit books. Examples below.

Simple action packed scenes that pack some punch.

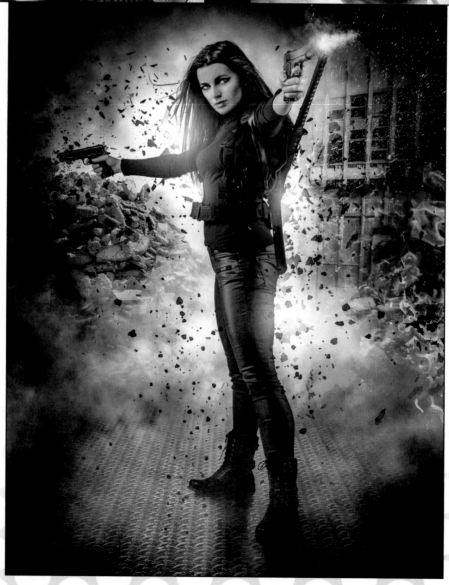

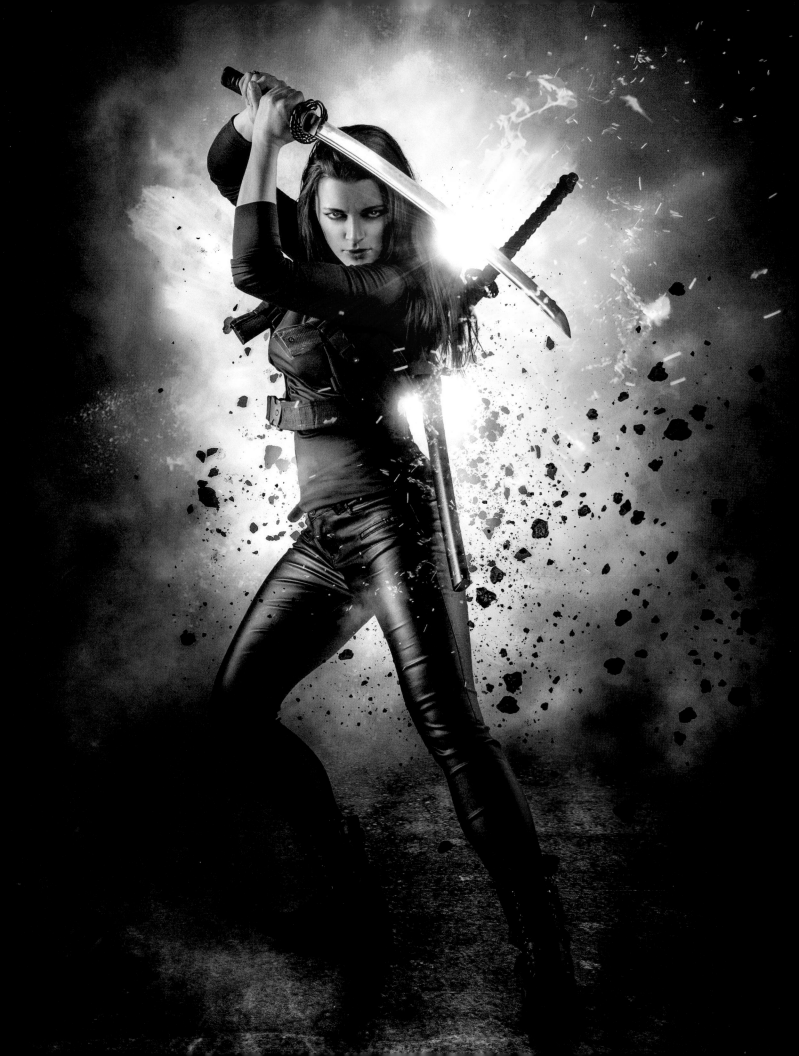

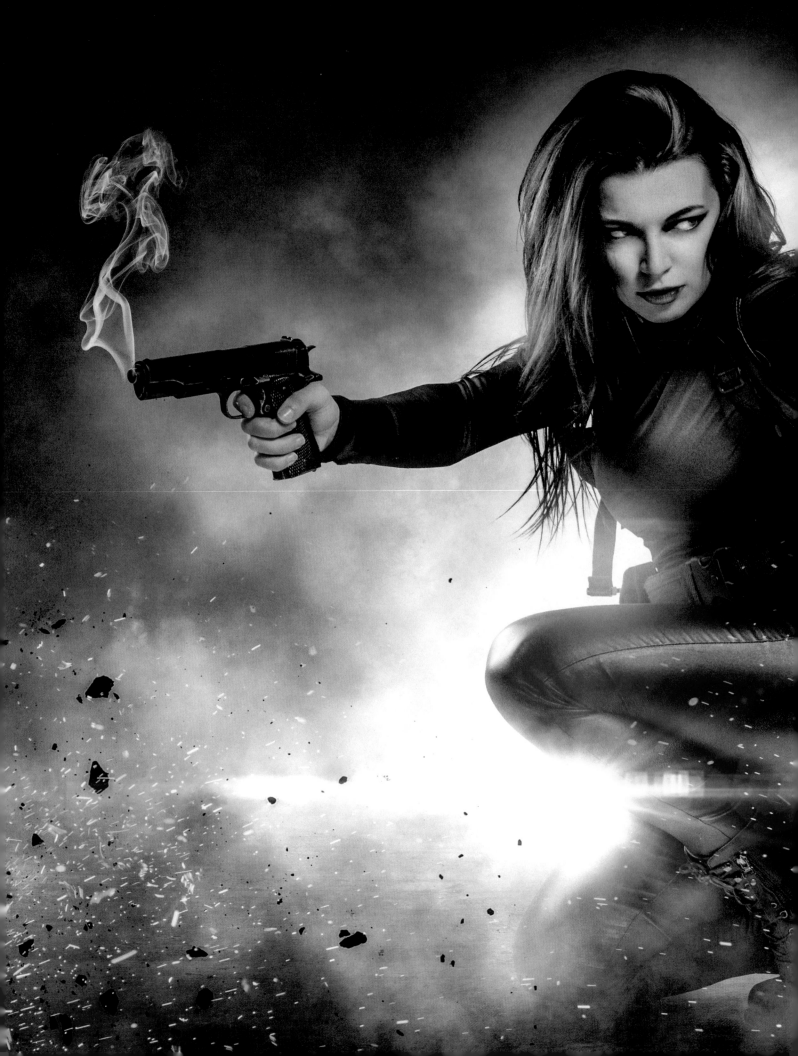

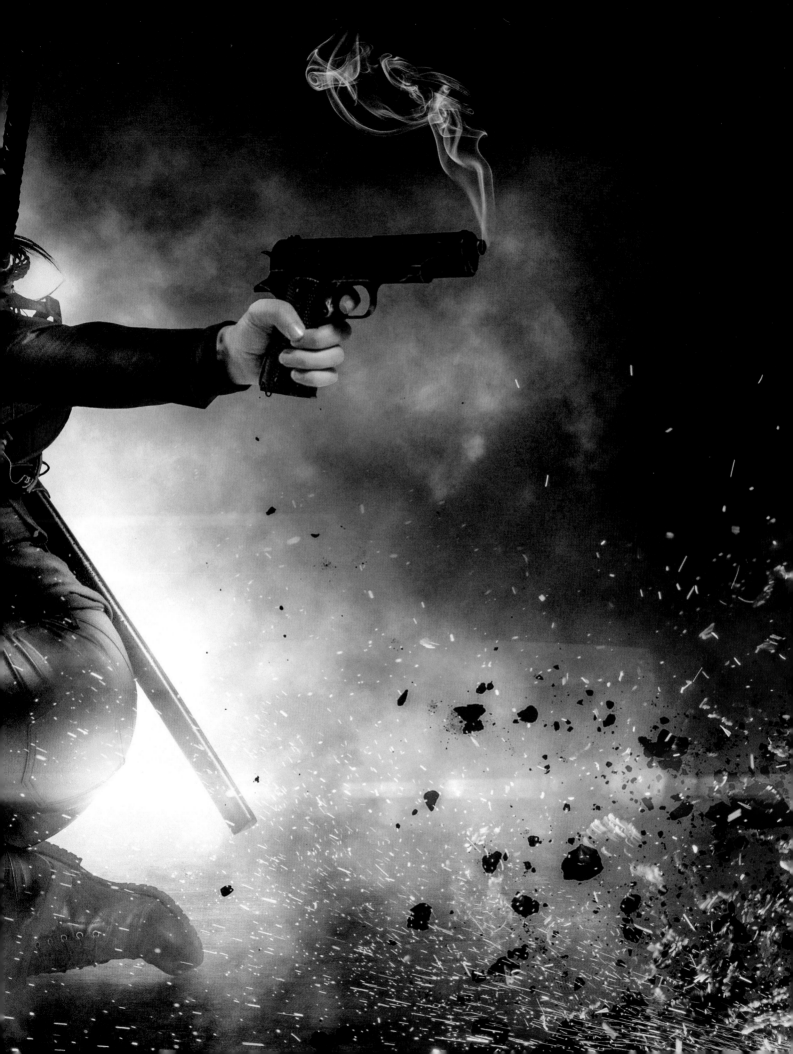

ABOUT THE ARTIST
ANDREW DOBELL

I have been fortunate to work with some truly creative people over the years, and being able to work on these covers has been a joy.

One moment sticks out to me though.
The moment Michael spoke about in his foreward.

Seeing other people standing and taking selfies of themselves with that banner, with Bethany Anne, really brought home to me how much these images mean to people, and I have to say, I got a little emotional.

I hope to keep on creating these Artworks for years to come.
In the meantime, please check out my own novels, all of which can be found on Amazon.
Thank you.

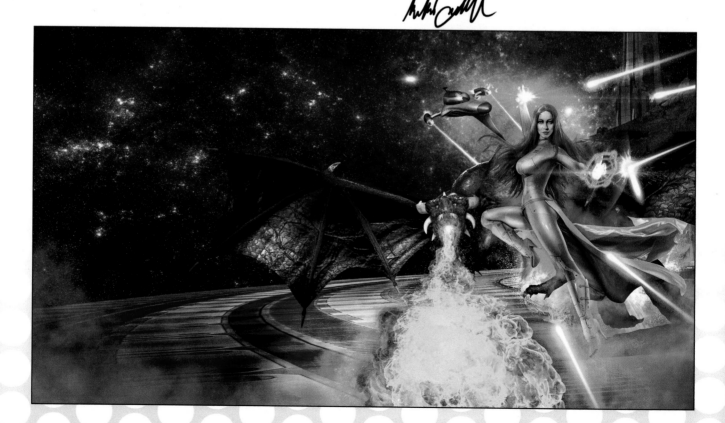

Books By Andrew Dobell
Available on Amazon

The Magi Saga - Urban Fantasy
Magi Dawn: The Magi Saga Book 1
Magi Rising: The Magi Saga Book 2
Magi Omen: The Magi Saga Book 3
Magi Edge: The Magi Saga Book 4
Magi Odyssey: The Magi Saga Book 5
Magi Descent: The Magi Saga book 6
Magi Rebirth: The Magi Saga book 7

Star Magi Saga – Space Fantasy
Maiden Voyage – Prequel
Star Magi – Book 1

Wasteland Road Knights – Post Apocalyptic
Liberation - Book 1
Exploration - Book 2

The New Prometheus - Cyberpunk
The New Prometheus - Book 1
The Prometheus Gambit - Book 2
The Prometheus Trap - Book 3
Prometheus Vengeance - Book 4

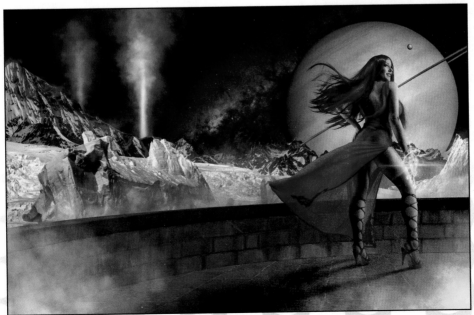

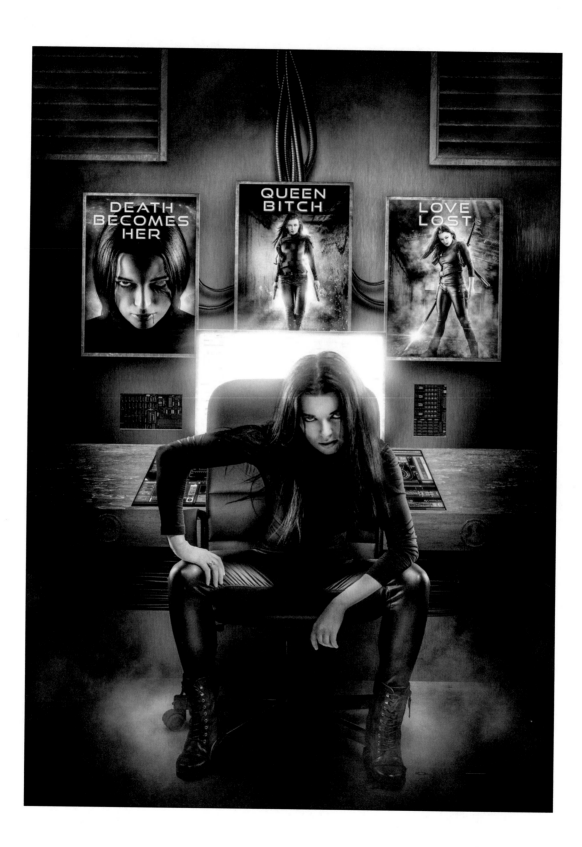

Made in the USA
Middletown, DE
11 October 2018